EBERHARD RUHMER

GRÜNEWALD

DRAWINGS

GRÜNEWALD

DRAWINGS

COMPLETE EDITION

BY EBERHARD RUHMER

PHAIDON

© 1970 PHAIDON PRESS LTD · 5 CROMWELL PLACE · LONDON SW7

PHAIDON PUBLISHERS INC · NEW YORK
DISTRIBUTORS IN THE UNITED STATES: PRAEGER PUBLISHERS INC
III FOURTH AVENUE, NEW YORK, N.Y. 10003
LIBRARY OF CONGRESS CATALOG CARD NUMBER: 69–12791

TRANSLATED FROM THE GERMAN
BY ANNA ROSE COOPER

SBN 7148 1372 9
TEXT PRINTED BY WESTERN PRINTING SERVICES LTD · BRISTOL
PLATES PRINTED BY HENRY STONE & SON LTD · BANBURY · OXON
MADE IN GREAT BRITAIN

CONTENTS

PREFACE

It is not the purpose of this book to present a review of all the abundant Grünewald literature or to assess the conclusions arrived at from studies of his drawings. This task has already been accomplished in the most recent publication of his drawings by Lottlisa Behling, *Die Handzeichnungen des Mathis Gothart Nithart genannt Grünewald* (Weimar, 1955), which includes the latest discoveries—both the undisputed Grünewald drawings in Berlin and the highly controversial ones at Marburg. Her painstaking summary is distinguished no less by profound erudition than by the cautious reserve she displays in voicing her own interpretation of the facts.

The present study, while accepting as a firm basis the convincing results of previous research, is intended to present an independent interpretation of established facts which may, it is hoped, open up fresh lines of thought. In view of the important examples of Grünewald's draughtsmanship which have recently been discovered, this seems to be a worthwhile task. Consequently, the catalogue and appendix (pp. 79–99) list only writings featuring either factual research, or hypotheses and conclusions with which the author is in agreement, rather than the complete list of publications to be found in the Behling work. In other words, we steer clear of reviving the old controversies, and the only material which will be considered here is that accepted by the author as valid on the grounds of his own or others' research. The picture presented by the present publication is, therefore, if not unchallengeable, at least fairly consistent.

M. J. Friedländer, Guido Schönberger, W. F. Storck and L. Behling have given us monographs on Grünewald the draughtsman. M. J. Friedländer, E. Holzinger, G. Schönberger, W. Stengel, Friedrich Winkler, W. K. Zülch, W. Timm and others have singled out for special attention the finer points relating to chronology, iconography, technique and attribution. Moreover, since the publication of the fundamental work by H. A. Schmid (Strasbourg, 1908–11), the drawings have usually been included in the more comprehensive Grünewald monographs. Throughout this extensive literature, great progress has been made in the chronological and intellectual analysis of Grünewald's art as represented by his drawings. His graphic genius obviously demands its own standards of value and interpretation, and many original and convincing contributions have been made towards an intellectual and technical characterization of his draughtsmanship. Yet one thing seemed to be lacking—an attempt at a firm and credible historical classification of the style of Grünewald's drawings. This seemed to me a task which had to be undertaken, if only to stimulate further research.

It is my hope that the present volume, while deeply indebted to previous research ranging over half a century, will find a suitable niche in the large and distinguished body of Grünewald literature.

GRÜNEWALD THE DRAUGHTSMAN

AN ATTEMPT AT AN HISTORICAL CHARACTERIZATION OF HIS STYLE

<center>I</center>

THE transition from medieval to modern times was accompanied in Europe by a fundamental spiritual upheaval which lasted for over a century. There were considerable variations in the degree to which different nations responded to the manifold problems of their cultural adaptation to the spiritual renaissance. Whereas there was little difference between North and South in the tempo of emancipation from the restraints of clericalism in the field of new discoveries, scientific and technical progress, the South was ahead of the North by nearly a century in the visual arts. The reason for this may be found in the greater flexibility of the clergy in Italy, which allowed new ideas to be woven into the fabric of religious traditions. Moreover, the secular powers in Italy rivalled the religious Establishment in fostering culture and the arts. In the North, on the other hand, the Church remained, with few exceptions, the dominant patron of the arts, at least up to the Reformation. Compared with the South, therefore, the arts were inhibited in their development, particularly in Germany, England and even France, where the Church continued to adhere to medieval patterns of thought with a stifling tenacity. This may explain why late development in these countries led to reformation—i.e. revolution—rather than integration.

Not surprisingly, the transition from medieval to modern times found its first expression in the realm of language. It is no coincidence that in the Italy of Dante, Petrarch and Boccaccio, Latin, the universal language of the Church, was gradually displaced in the domain of poetry by the vernacular, which proved to be a more sensitive vehicle for the expression of the new spirit. Similarly in the North—though considerably later—Martin Luther created German poetry expressive of the new spirit, from Bible texts, psalms and the words of medieval Church music.

We could expect a graphological analysis to determine whether this spiritual upheaval resulted in a visible change in *handwriting* and to describe the nature and degree of this change. Such an analysis might also reveal the deeper significance of the new spirit: more individualistic and subjective forms of communication—sensitive seismographs of a greater psychological complexity, subtler intellectual distinctions, which had developed in response to the many new challenges arising from the radical changes of the era.

In this context, we are only concerned with what one might term an 'artistic graphology', expressed in the calligraphy of the painter's brush or the sculptor's chisel, and—even more directly and therefore revealingly—by the draughtsman's pen, silver-point or ink brush.

Early European drawing, from about 1400 onwards, is very much in vogue with present-day art historians. Not only collectors, but the art-loving public in general, have developed a most intimate relationship with these subtle and delicate self-revelations of the modern era at its earliest stage. The draughtsman applies his pen, chalk or metal-point cautiously, self-consciously, almost irresolutely; as if to attenuate the stroke itself, he fades it out in carefully graded nuances of shading. With increasing confidence and sureness of draughtsmanship, both outlines and plastic hatchings begin to assert

<center>9</center>

themselves as pure means of artistic expression. Stylized patterns emerge from combinations of parallel strokes and soft curves. Already we have continuity, fluidity of line; now calligraphy condenses into style. But on closer examination, we perceive that these sickle-shaped curves ending in curlicues, which make up the body contours, drapery folds and hair, are in fact the result of painstaking labour. The nervous, irregular vibrations of this calligraphy betray an almost feminine timidity, an emotional uncertainty. While the flow of outlines is inescapably revealed in every sculpture and painting of the period, hatched drawing—obviously a secondary, derived art form, or at any rate an abstraction—anxiously strives to accommodate itself to the accepted 'soft' style of international Gothic in a medium for which the tools are not really suitable. Even in these earliest graphic documents of the North, a certain mannerism is detectable. Those softly gliding curves of folds and wavy hair have not yet grown organically from the natural calligraphy of a creative personality which involuntarily manifests its sovereign mastery in the routine of line, but from a preconceived, utterly medieval ideal of form. Completely lacking are dexterity, bravura, élan, swift assurance and unerring spontaneity.

We find these qualities in Italy most prominently in the famous drawings dating from c. 1400, for instance the multifigure study in silver-point attributed to Michelino da Besozzo, the *Adoration of the Kings* (Albertina, Vienna), and also in Fra Angelico and Jacopo Bellini. In the North, with its later development of the art of drawing, these qualities do not appear until c. 1500 with Schongauer, Holbein the Elder, the early Dürer, and Cranach.

Judging from those examples of early fifteenth-century drawings which have survived, we can perceive a new trend in the pen drawings of Stefano da Verona. In contrast to Michelino da Besozzo—a timid draughtsman, though fairly self-assured as a painter—Stefano da Verona displays in his paintings a medieval passion for meticulous detail, but the drawings attributed to him have a touch of genius in their deliberate cultivation of smooth, briskly concentrated strokes of the pen. His well-known drawing—perhaps the most charming—the *Caritas* (Uffizi, Florence) shows, nevertheless, that Stefano, too, works from preconceived forms which, in this case, are decidedly plastic. But his illusionist virtuosity speaks to us in a new, liberated language, that of the conscious personality. With an almost somnambulistic accuracy, he tosses on to the paper grandly conceived figures, with the folds of their garments boldly underlined by light and shade. This self-assured style suddenly proclaims an absolute formal certainty, showing off with deft sleight-of-hand; the brisk stroke seems to declaim theatrically: 'This I can do! I am jotting this down in haste but am certain of success.'—It is this personal, private mood that marks the novelty of such notations compared with the painstaking repetitiveness of the fixed formal conventions of earlier draughtsmen. The draughtsman of the new generation, while not exactly baring his soul, does reveal his temperament, his whims, and this with such immediacy that it has a direct impact on the beholder. Stefano's self-assured calligraphy foreshadows the style of the Renaissance.

Perhaps the subjective calligraphy of Stefano and other masters of that time would not have flourished as it did, but would have degenerated into a superficial virtuosity, had it not been for the demand for a naturalism faithful in every detail which dominated the latter part of the fifteenth century. This is true especially of the Netherlands and Italy, where the art of drawing flourished in studies and sketchbooks 'based on nature', thus enriching traditional painting by new motifs and graphic complexity. This enrichment of the substance, however, brought with it an impoverishment of the standard of calligraphy, a loss in virtuosity of line, in decorative effect, and in the expression of

subjective feelings. These defects are evident in Jan van Eyck's *Cardinal della Croce* (Berlin), in Pisanello's and Uccello's drawings, in Jean Fouquet's *Guillaume Jouvenel des Ursins* and in the diligent work of Hans Holbein the Elder. Particularly the northerners adhere to a disciplined line in their drawings, registering optical sensations with cool precision. Pisanello even returned to the somewhat hesitant brittleness of early drawing technique, perhaps as a result of his faithful adherence to a model, drawn either from other works of art or from nature. These same elements recur much later in the work of the German naturalists: in the drawings which Dürer made in the Netherlands and the portraits by Hans Holbein the Younger.

At this point in history, the development of the art of drawing—largely harnessed to the reproduction of the minutiae of nature—appears to suffer a set-back. For a time, there is no independent draughtsmanship with its own laws, aims and forms of expression, at least as far as one can make out from the reduced number of works which chance has preserved for us. The draughtsmen of the High Renaissance in Northern Italy and Florence were sharp-eyed students and stylists applying well-tested and successful formulae. Reduced almost to sketches, their drawings were purpose-orientated, so that this calligraphy conveys little personal testimony. A few exceptional artists left us so many drawings that we may regard their choice of this medium as an indication of their feeling that Renaissance man's urgent need for creative self-realization could best be expressed through drawing. Mantegna—undoubtedly the greatest draughtsman of the quattrocento—must be left out of this study because of the small number of authentic graphic works that have come down to us. But we can study Marco Zoppo, Mantegna's friend (with about a hundred sheets extant), Benozzo Gozzoli, Filippino Lippi (with a considerable number of drawings, which have not yet been critically sifted), or Carpaccio (with over fifty surviving graphic works). In addition, there are two prolific draughtsmen: Fra Bartolommeo, and last but not least, Leonardo, one of the greatest draughtsmen of all time. As a graphic master, he transcended the accepted language of the quattrocento in only one respect, namely in the development of scientific illustration. Though not strictly an art form, it came entirely within the orbit of early Renaissance culture. Of all these masters, it is the least known, Marco Zoppo, who cultivated the seed sown by Stefano da Verona, which eventually came to flower in Raphael, Michelangelo and Dürer. Zoppo's virtuoso pen drawings in his London *Sketchbook* convey a sense of pure joy in beautiful form and ease of achievement. The London *Sketchbook* is a *tour de force* of bravura and deftness, displaying a self-confident command of reality to a degree where draughtsmanship scintillates in playful and witty flashes of spontaneous excitement, in psychograms of a quick and ardent temperament, even though on occasion these means of expression are exploited to the point of exhaustion.

With this characterization, we have established a conceptual link with the stage of historical maturity of drawing as an autonomous discipline, represented by the three artists mentioned before: Michelangelo, Raphael and Dürer. It is well known that the two latter used to exchange drawings with each other, with the declared intention of 'showing their hand'. One can safely assume that the purpose of these exchanges was neither the illustration of spiritual content nor a demonstration of the artists' ability to render a faithful reproduction of natural forms. 'Showing one's hand' really meant that these two leading masters of the early sixteenth century were competing against each other in virtuosity, elegance and subjective originality which, together, created the 'grand manner' of draughtsmanship. Each man is proudly conscious of his personality and of his tremendous artistic power to

produce visual works which almost match the perfection of divine creation. A 'plus' in dexterity and bravura is equated with a 'plus' in the power of his personality. Thus, with every stroke of the pen, chalk or brush, the three masters at the summit give a conscious graphic manifestation of the highly-bred artistic personality, an expression of 'self'.

A logical consequence of such absolute cultivation of draughtsmanship for its own sake, and as a demonstration of the artist's personality, was the extreme mannerism of the Florentines around Pontormo and Rosso, and of the North Italian school of Parmigianino and Tintoretto. The same is true of the cult of mannerism in the styles of the Baroque and Rococo, which was most strikingly revealed in graphic art between 1500 and 1800.

Where then is Grünewald's place in the development of European drawing, the progression of which we have briefly outlined from medieval formalism through late Gothic and early Renaissance naturalism, to the highly developed mannerism of the Renaissance and Baroque? He was born about 1470—an earlier date, accepted for many years, remains unproved—and died in 1528, so that he must be regarded as an exact contemporary of Albrecht Dürer, and a little older than Michelangelo (1475–1564) and Raphael (1483–1520), whom he outlived by eight years. The great draughtsmen of Marco Zoppo's period died around the time of his birth. Chronologically, Grünewald can thus be accurately placed within the evolutionary period which we have described as the qualitative zenith of the absolute manner in draughtsmanship, rather than its most extreme point. Yet he stands out as a lone stranger in the contemporary art scene. The style of his drawings is often far from mannerist, in contrast to his paintings, which are not devoid of certain echoes of the widespread stylistic extremes characteristic of the early sixteenth century; as, for example, in his *Crucifixion* (Washington) or in his *Maria-Schnee* altarpiece (Our Lady of the Snows) at Freiburg im Breisgau.

This absence of mannerism is most exceptional in a German artist of Dürer's time. We are too easily inclined to label as German, or perhaps 'nordic', a certain grand manner in draughtsmanship, exemplified by briskly drawn curves, accentuated rhythm and elegance of line, a commanding gesture of the hands, a self-assured posture amounting to a style which aims at a grand effect, even at the expense of naturalness. This Northern art was undoubtedly the main influence in the decline of the Italian Gothic style of drawing with its somewhat feminine and impersonal formalism. Pisanello's naturalism may be explained largely by this influence, and the highly developed Emilian draughtsmen of the late quattrocento were demonstrably inspired by the North. We chose Marco Zoppo as their most notable representative because of the large number of his graphic works that have survived. While the North had not yet achieved the swift and confident line which distinguished Italian draughtsmanship, its advanced technique of graphic reproduction with a wealth of accurate detail made Northern art widely accessible. Zoppo in his turn gave such a free and masterly interpretation of the style that, as early as 1460–70, his drawings evoke the mature drawings of Albrecht Dürer rather than those of his Italian contemporaries. The extent to which Italian mannerism of the sixteenth century is indebted to the North—particularly to Albrecht Dürer—is well known.

To sum up, while this grandiose style of mannerist drawing was specifically German and undoubtedly at its apogee in Grünewald's lifetime, we must remember that he was an artist who stood in a class by himself. This 'otherness', coupled with his qualitative superiority, establishes the greatness of Mathis Grünewald as the master-draughtsman towering above his contemporaries and his background.

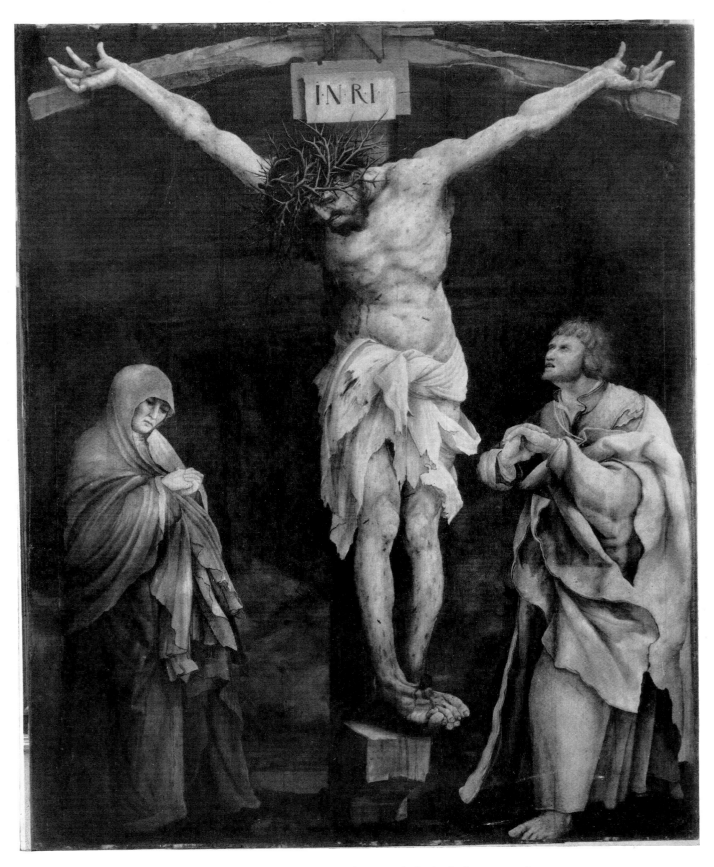

Fig. 1. The Crucifixion. *Karlsruhe, Kunsthalle.* (Cf. plates 1, 2, 5)

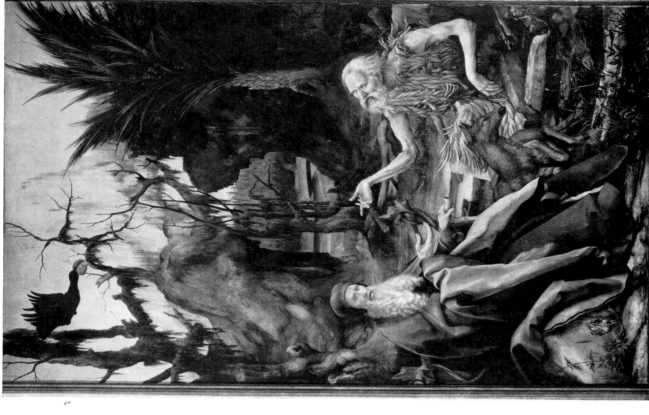

Fig. 3. The Meeting of Saint Anthony and Saint Paul the Hermit,
from the Isenheim altar-piece. Detail. *Colmar, Musée Unterlinden.*
(Cf. plates 24, 25, 27)

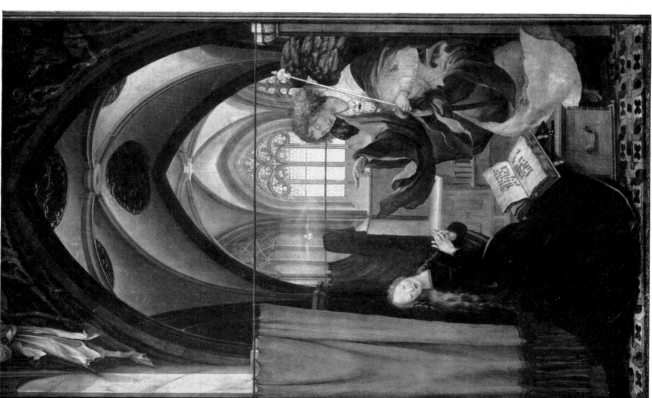

Fig. 2. The Annunciation, from the Isenheim altar-piece. Detail.
Colmar, Musée Unterlinden. (Cf. plate 4)

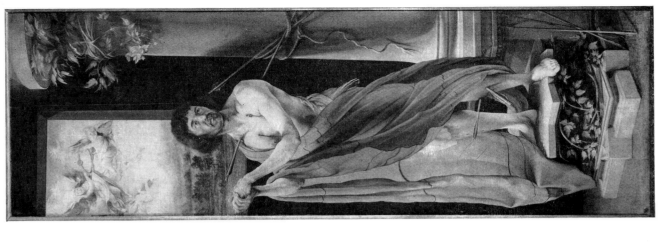

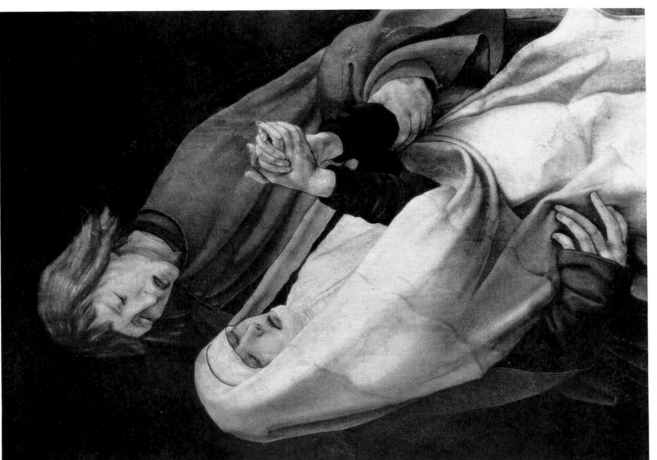

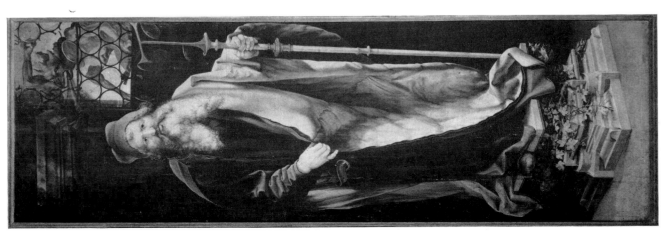

Fig. 4. St. Anthony, from the Isenheim altar-piece. *Colmar, Musée Unterlinden*. (Cf. plate 31)—Fig. 5. The Virgin and St. John the Evangelist, from the Isenheim altar-piece. Detail. *Colmar, Musée Unterlinden*. (Cf. plate 16)—Fig. 6. St. Sebastian, from the Isenheim altar-piece. *Colmar, Musée Unterlinden*. (Cf. plates 22–23)

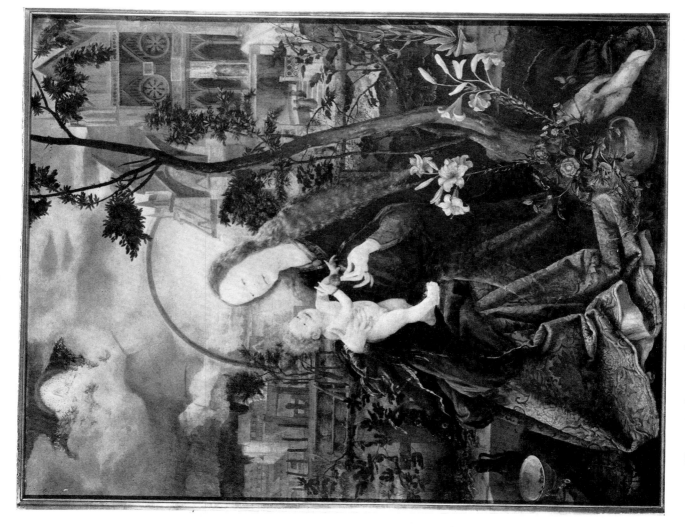

Fig. 8. Madonna in the Garden. *Stuppach near Mergentheim, Parish Church.*
(Cf. plates 28 and 33).

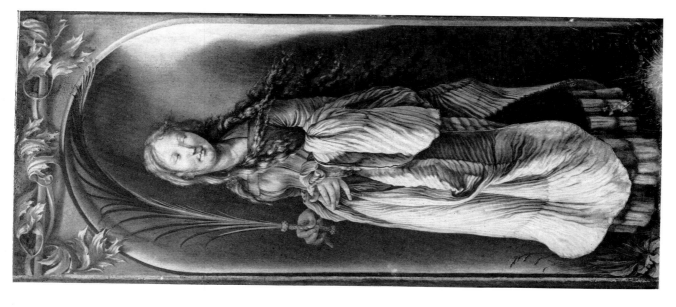

Fig. 7. St. Lucy (?). *Donaueschingen,
Fürstenbergische Galerie.* (Cf. plate 13).

IF Grünewald the draughtsman is so fundamentally different, what is he like? How can we define the specific, individual characteristics of his art and establish concrete criteria for a Grünewald 'original' which will enable us to differentiate between the authentic work and the misattribution?

In almost complete agreement with other serious researchers, we accept those works as coming from Grünewald's own hand in which we can distinguish basically homogeneous features although, of course, there are superficial variations in his fundamental style. These variations depend on factors such as period of origin; difference in purpose (i.e. sketches made for possible later use in paintings, sometimes with considerable modifications, or compositional sketches intended for a particular work); differences in technique (pure chalk drawing, chalk heightened with white on light or tinted ground; chalk with water colour; scumbled chalk; pen drawing). Whether the drawing was from a model or not, would be another factor affecting the style. Such differences, which are not of an essential nature, will in this context not be treated as characteristic criteria. For the purpose of definition of the essential character of Grünewald's drawings, we classify his drawings as follows:

Detailed studies drawn from models;

Deliberately stylized model studies;

Rapid sketches from nature, also based on models;

Finished drawings in their own right (i.e. not intended as preliminary studies for paintings);

Purely compositional sketches for a projected painting.

It is the aim of this study to ascertain the characteristic features of Grünewald's drawing technique, irrespective of differences due to chronology, purpose etc., and to draw conclusions as to the essential nature of Grünewald as a draughtsman.

As an example of a carefully detailed study drawn from a model, let us consider the *Arms of St. Sebastian* for the St. Sebastian wing of the Isenheim altarpiece (Plates 22, 23). Unlike Albrecht Dürer, Grünewald obviously had no preconceived ideal norm in mind, but allowed himself to be surprised by the unique, accidental features of some male model, probably of undistinguished appearance. This drawing communicates his 'surprise' by agitated, sensitive strokes, guided by intuition rather than by intellectual concentration. This sheet conveys almost a feeling of colour. Instead of pinpointing functionally important parts (as Dürer did), he emphasized with firm, dense strokes those spots which aroused his interest by their expressive ugliness. This is evident in the intensive treatment of creases in the elbow and armpit, the exaggerated sharpness of the elbow, and the gross thickness of the stubby fingers. On the other hand, the vague modelling on the chest and in the shaded part of the left upper arm and right forearm is in contrast with an over-emphasis in other parts. Some of the modelling is somewhat pale and negligent, resulting in an uneven and patchy effect overall. This does not produce a unity of graphic design but an emotion-laden, arbitrary selection of detail.

It is even more instructive to examine his technique of line, both in contours and hatchings. It bears all the signs of a direct copy from nature. The influence of Dürer leads us to expect firm, unbroken, flowing lines in any German drawing of the early sixteenth century. Dürer's hatchings, in particular, are deliberate and planned, even when he uses soft material such as chalk, charcoal or brush. His lines are taut, the curves tensioned in parallel regularity, following the rise and fall of a surface with directness and ingenuity. He achieves areas of darker intensity by crossing his lines in a regular pattern.

Dürer indulges in a beguiling interplay of sophisticated, elegant lines with the obvious intention of dazzling and impressing his public. The same may be said of nearly all the important draughtsmen of his time in Germany, Italy and, perhaps less so, in the Netherlands.

In comparison with these examples, the fundamental difference of Grünewald's modelling technique becomes all the more evident. His hatching strokes give an impression of timidity, nervousness, almost carelessness. Parallel and cross lines are irregular, uncertain and unco-ordinated; the pattern of lines scarcely describes the rise and fall of surfaces. If these hatchings were firmer and darker, one would be bound to notice how explosively they run counter to the flow of natural curves. Grünewald the draughtsman might be described as 'the feeling eye'; he 'forgets' facts which are, of course, perfectly well known to him, but his vision of reality produces such a heightened awareness in him that a routine formula would be a distortion. His will, his intellect and his artistic experience yield to the impetus of the thing seen.

The second category, of stylized model studies, is most aptly represented by his *St. Catherine* (Berlin; Plate 36). First of all, we must ask ourselves what sort of 'model' he used. As in many of his other drawings in this group, the first thing that strikes us is that only parts of the garment have been fully executed. The rest is not much more than a sketch, and possibly the product of free invention. Could it be that inside these garments there was no living body, but a lay figure? After all, no live model could have managed to keep absolutely still long enough for the artist to put down on paper in such an intensive and accurate manner this complicated and richly detailed cascade of pleats and folds. Yet even this fall of pleats—is it really 'natural'? Does it not look as if the material were frozen into immobility at the pitch of some unusual agitation? This effect allows of two explanations: either Grünewald made a preliminary sketch of this pompous drapery, which he had undoubtedly seen and not vaguely invented, completing it later from memory guided by his formal sense of style, or the artist, who loved experimenting, used some hardening process on naturally draped materials. (A third possibility is mentioned on page 25.) At any rate, a new feature emerges in Grünewald's drawing technique. Whether the drapery is exposed to light or lying in the shade, it is completely covered over with surprisingly regular layers of strokes, either sharply divergent, flowing in broad strands, or broken into hard angles. Unlike the intuitive calligraphy which characterizes the live nude model study of St. Sebastian, this is an example of deliberate graphic work. It is not formalistic or intellectual in the sense in which we describe Dürer's work, but rather spiritual in concept. A similar approach, though in a more extreme form and thus more unequivocal, distinguishes the graphic work of a great modern artist: Vincent van Gogh. Their essential common bond is a more or less complete coverage of all areas by fairly regular layers of strokes which, far from being static, are in dynamic movement. Both Grünewald and the modern pre-expressionist master make conscious use of this means of graphic expression. In spite of the noticeable stylistic schematization, Grünewald retains his 'anti-calligraphic' manner of hatching, which is deliberately hard and unaccommodating. It expresses his nervous sensibility and aversion to smart bravura and amiable elegance.

As an example of our third category—a rapid sketch based on a model—let us consider the *Female Saint* (Plate 38) which appears on the back of the St. Catherine drawing previously discussed. Spirited on to the paper with ineffable lightness, it exemplifies Grünewald's utter indifference to contours, firm modelling or material details. No longer can we feel a 'master's hand' in the traditional sense, and this is obviously by deliberate choice. One is tempted to ask in what state of entrancement—so unusual for

an old master of Dürer's time—in what mood of indifference to palpable qualities, Grünewald conjured up this fleeting impression of a young girl's figure. This deliberate affront to accepted taste in such a subjective, highly personal manner will not be found again until the Baroque period—or more precisely, until the end of the nineteenth century. Thin, diffuse lines, drawn with a trembling hand, give the merest hint of face, hair and fragmentary drapery. With utter unconcern, the artist has roughly marked the shaded parts of the skirt with long and regular chalk strokes, and then dipped his brush in water colour or chalk dust to create grey shadowy areas of transparent delicacy, in irritating contrast to the more intensive darkness of the modelled shade. In this drawing, we again find an effect of patchiness bordering on the abstract, with no vestige of the bravura, calligraphy, and the swaggering stance so prominent in Dürer's work.

This tendency is seen at its most extreme in Grünewald's *Virgin and Child with the Infant St. John* (Plate 33), which is the only authentic example of its kind to represent our fifth category: a purely compositional sketch. With its shaky contours and scrawls to suggest the lines of folds, this work hints only vaguely at modelling in depth. If we imagine Dürer as a draughtsman whose keen observant eye was served by a firm, vigorous hand, then Grünewald emerges from this inspired scribble as an absent-minded dreamer, his gaze filled with distant visions, his trembling hand covering the pages with nervous improvisations. This highly subjective sketch is in striking contrast to the style common among master-craftsmen well into the sixteenth century. It comes straight from the core of the artist's being, and there is no attempt at 'greatness'; Grünewald here expresses a flowing fundamentalism. We can assume that he was not prone to unworldly eccentricities in his social behaviour, and only indulged in the luxury of such an advanced form of expression in this relatively unimportant case because these 'scribblings' were not intended for the eyes of others. Nevertheless, we have every reason to believe that other contemporary draughtsmen did not let themselves go with such abandon, even at times of greatest unselfconsciousness. This hurried sketch of a composition does not possess any palpable formal qualities; with the exception of the Virgin's head, one might almost describe it as deliberately 'unschooled'. At all events, it is a testimony to an absolute freedom from all accepted standards of values.

We deliberately refrain from concluding our analysis of Grünewald's drawing techniques with this example of extreme freedom in order to avoid creating a false image of the actual direction of his artistic development. To construct a direct line of descent from this drawing to Klee would be an unjustified extrapolation. The old master rarely indulged in bold, free-ranging excursions such as this most private sketch. All his extant paintings speak to us quite clearly of his ambition, as a painter, to simplify and consolidate (e.g. the *Crucifixion*, Karlsruhe). This brings us to the group of his drawings which were finished works in their own right, of a more or less official character, intended for public view—perhaps commissions, or at any rate drawings executed in parallel with his paintings, not as preliminary studies. This group includes all of Grünewald's portrait drawings as well as complete compositions, an example of which is the *Holy Hermit* (Plate 32) in the Albertina, Vienna. In its conception and degree of execution, it is comparable with the grisailles of the Heller altar in Frankfurt and Donaueschingen. Perhaps it was intended to demonstrate the possibilities of a grisaille painting to one of his patrons. This *Hermit* does not embody any essential innovations compared with the other examples dealt with so far, and is graphically of little interest, being hardly more than an imitation of grisaille painting. The last facet of Grünewald's graphic style which we have to consider is illustrated

in his 'portrait' studies of heads. An example is provided by the supposed *Guido Guersi* (Plate 14). In many of the details we find the same characteristics as in the model study of *St. Sebastian* (Plates 22, 23), with which we began our investigation. Both contours and hatchings betray a sensitive hesitancy, a nervous delicacy, yet a meticulous observance of detail. Accents are curiously sporadic, accidental and patchy. In this case, the result is an enhanced expressiveness and direct appeal. This drawing is distinguished by an unusually ornamental calligraphy, especially in the elegant treatment of hair and beard—quite exceptional in a Grünewald.

One might almost be reminded of Dürer in this respect, but this impression does not stand up to direct confrontation with a comparable Dürer drawing: e.g. the well-known study of *St. Jerome* of 1521 (Albertina, Vienna). In such a juxtaposition, the conclusion becomes inescapable that even where Grünewald wants and ought to behave in an 'official' manner—and where he might possibly find himself in open competition with Dürer—he remains the artist whose most conscious and deliberate creative efforts are dominated by the imponderables of a subjective and spontaneous working method, in contrast to Dürer, whose self-discipline subordinates personal factors to the demands of style, of 'hand' and of a polished representation. In comparison with Grünewald, Dürer is a giant of diligence, applied intensity, dexterity and graphic assurance. But against Dürer's perfection, one must admit Grünewald's equal eminence in his creative rejection of prejudice and his elasticity, which accepts as possible all and any phenomena, his unlimited curiosity probing with delicacy and honesty into the most surprising situations, accidents and exaggerations which nature inexhaustibly parades before his eyes. Dürer's attention is focused on this world; Grünewald is awake to the metaphysical. The expressive hesitancy of his hand produces an all-embracing language of drawing.

Once this is appreciated, and the real nature of Grünewald's manual 'uncertainty' and brittleness is understood, there is little room for doubt as to what is authentic in this uncharted graphic *oeuvre*, and which works bear only superficial resemblance to it. The drawings newly discovered in Berlin are undeniable Grünewald originals; and without having seen the originals, one can say with equal certainty that the drawings found at Marburg can by no means be claimed to be fully authentic. Surely there can be no question that the *Susanna* (Haarlem)—with its formal poverty and spiritual emptiness—lacks the incomparable sensitivity of a genuine Grünewald, as does the *Mother of Hans von Schönitz* (Plate 49) in the Louvre, which is disappointing in its graphic roughness and unassimilated realism. The only doubtful case, which is really open to discussion, remains the pen drawing at Stockholm (Plate 51), which has been attributed to the Master of Messkirch. While by no means a masterpiece, it must remain in doubt mainly because we do not possess an authentic pen drawing by Grünewald, so that we do not know how his usual soft style, based on the medium of chalk, would have been modified if he had taken up the pen, so popular in the Dürer period. One feature that would militate against the authenticity of the Stockholm *Madonna of Mercy* is a certain geniality and gracefulness of stroke which one does not expect in Grünewald's hesitant calligraphy. The category of Grünewald's compositional sketches is represented more reliably by his *Holy Family*.

Grünewald's drawings stand in complete isolation in their time, poised on a knife's edge between tangible quality and imponderability. He made no concessions to contemporary style, and only on rare occasions could he be suspected of competing from a distance with Albrecht Dürer's triumphant virtuosity. It is generally accepted that he did not wish to identify himself with the official style of draughtsmanship of the early sixteenth century, which was more or less dominated by Dürer. The

question then arises: was Grünewald's orientation international? Far from it! He obviously did not try to emulate the gaily sensuous, flowery calligraphy of Raphael and his followers, nor the plastic, massive style of Michelangelo's drawings and the mannerists of his school.

A different historical interpretation of Grünewald the draughtsman might be to regard him as a belated Gothic, a backward-looking conservative. This hypothesis would be based on the cobwebby delicacy of his drawings, the over-sensitive lack of firmness in his style, the roughness of his hatchings and the patchiness of the total graphic image, all of which could be described as faults which have been magically transformed by the power of genius into once-only valid virtues. Indeed, many art historians still classify Grünewald's *paintings* as 'late Gothic', which is certainly incorrect. Paintings such as the *Maria-Schnee* altarpiece (Our Lady of the Snows) in Freiburg, and the *Crucifixion* in Washington show quite plainly his close affinity with international mannerism. At times, one might almost regard him as a German Pontormo. We find mannerist echoes also in some of his graphic works, such as the scurrilous nude flute-player (formerly Koenigs Collection, Plate 35), which illustrates Grünewald's contemporary orientation. However, one cannot apply the label of mannerism to his graphic style, which we have traced as a constant factor throughout the different facets of his work as a draughtsman, without doing him a grave injustice and ignoring his unique position in the history of art.

Is he then a prophetic visionary, a forerunner of Rembrandt, of the impressionists or even of the expressionists? This question has not only been asked, but has been seriously answered in the affirmative. This too I would deny.

The conclusion I would draw from this present attempt at an historical classification, is that Grünewald the draughtsman stands, for his time, as a unique and absolute artist—in the same way and on the same level as Rembrandt or Bach, with both of whom he is linked by a deep affinity. Such greatness is possible at any time in history, but the subjective form in which it found expression could never have been understood more positively than in the twentieth century.

III

THE reflections in the previous chapter were intended to determine as far as possible the character of Grünewald's draughtsmanship—if only with the purpose of providing a yardstick for cases of doubtful authenticity. We must now go on to investigate whether the undisputed originals extant today can be brought into a chronological order. For a start, we must discount the notion, frequently voiced, that such a chronology can be worked out in exact agreement with the 'development' of other German contemporary draughtsmen, or based on research experience into the styles of other, better documented masters in their youth, maturity and old age. We must also warn against the temptation of assuming that drawings on both sides of the same sheet are necessarily contemporaneous. Finally, it is certainly not true to say that drawings subsequently used in paintings, either literally or with modifications, must in every case date from a period immediately preceding the execution of those paintings. On the evidence available, Grünewald sometimes worked for 'stock', without necessarily a particular commission to fulfil. Another possibility to be borne in mind is that Grünewald used the same drawing at different points in time for different purposes.

Nevertheless, our only means—however imperfect—of determining *approximate* dates of drawings,

remains the connection with paintings which are dated or the dates of which have been more or less accurately established. One can then often, though not always, deduce the *terminus ante* with some degree of certainty.

We must start with two drawings which illustrate our difficulty. Both are without any doubt connected with Grünewald's late painting of the *Crucifixion* at Karlsruhe (Fig. 1). They are *Christ on the Cross*, also at Karlsruhe (Plate 1), and the *Head of a Young Man Clasping his Hands* (Plate 5) in Berlin. The former is generally regarded as an early work; conjectural dates vary between 'before 1503' and 'around 1515'. The latter is considered by all writers as a late work—between 1520 and 1524—with the exception of Guido Schönberger, who regarded it as contemporaneous with the Isenheim altarpiece. When compared with all the other Grünewald drawings, the Karlsruhe *Christ on the Cross* does indeed seem to be an early work; on the other hand, the expressive *Head* at Berlin is without question one of Grünewald's earliest graphic works known to us. I would go so far as to say that the formation of nose and eyes contains almost primitive elements, such as are to be found in the *Mocking of Christ* of 1503 (Munich). Since, moreover, this *Head* was not used in its original form any more than the *Christ on the Cross*, but both have been freely adapted in the painting, the only firm conclusion that can be drawn, in the absence of more concrete evidence, is that the drawings antedate the painting. These studies were either drawn for 'stock', or in preparation for considerably earlier paintings which have not survived, and were later brought out again for this *Crucifixion*.

Another very early work is, undoubtedly, one of the studies for a *Virgin of the Annunciation* (Plate 4) in Berlin. While certain essential elements in the posture and the fall of the drapery have clearly been incorporated into the *Annunciation* of the Isenheim altarpiece (Fig. 2)—about 1515—the drawing is quite unrelated to the other preliminary works for the Isenheim altarpiece. In their broad simplicity, the lines and the treatment of folds show great similarity with the Frankfurt drawings dated not later than about 1511 (Plates 6–11). On the other hand, the head, tenderly drawn with its softly curling hair, is pure late-Gothic, both in execution and expression. (A comparison with the similar head of *St. Dorothy*, Plate 13—which is generally regarded as late, about 1511 at the earliest—will illustrate the difference between late-Gothic and individualistic styles.) While working on the Isenheim *Annunciation*, Grünewald used the old drawing—possibly made some ten years before—and incorporated it with modifications.

I think the *Drapery Study* (Plate 3) may be earlier still. With modifications, it was used again in the Virgin's gown in the Isenheim *Nativity*.

We reach somewhat firmer ground only when we come to consider the male drapery studies on Plates 6–11. As explained in the Catalogue Notes, scholars are mostly agreed—and with some justification—in assuming that these were model studies for the *Transfiguration of Christ* which Grünewald painted for the Dominican monastery at Frankfurt in 1511. It is inconceivable that model drawings of such precision and purposefulness, with such specific postures and gestures, should have been executed simply for 'stock', without a definite aim in sight. They point quite definitely to the composition of a *Transfiguration*—perhaps a compositional sketch in the manner of Plate 51. Since the 1511 *Transfiguration* is no longer extant, we will never be able to say with absolute certainty whether these drawings were really intended for this particular painting. At any rate, the connection and thus the date (about 1511) are so probable that it is possible to accept this without serious reservations.

We are on even firmer ground when we deal with the drawings which have an unmistakable con-

nection with the Isenheim altarpiece. These are: the *Woman Mourning* at Winterthur (lower arms and hands, Plate 16; cf. Fig. 5); the *Torso of St. Sebastian* at Dresden and Berlin (Plates 22, 23; cf. Fig. 6); the two *Hermit* studies at Dresden and Berlin (Plates 24, 25; cf. Fig. 3); the so-called *Self-Portrait* at Erlangen (Plate 27; cf. Fig. 3); and the *Virgin of the Annunciation* at Berlin (Plate 4; cf. Fig. 2). Other studies which are often regarded as being connected with Isenheim show so vague a relationship that we cannot consider them in this context. There is a date on the *Crucifixion* wing of the Isenheim altarpiece: 1515. Taking into account all relevant data, the work on the Isenheim altarpiece must be presumed to have been carried out about 1514–15. This is also the probable date of the Isenheim drawings, except where they show material differences in style and technique. In such cases, one can assume that Grünewald fell back on earlier drawings which he may have done as preliminary studies for other compositions, or studies of a general nature.

The study for the *Virgin of Stuppach* (Plate 28; cf. Fig. 8) can be assigned a probable date on different evidence, but again with little certainty. On repeated consideration of the ambiguous problems posed by the *Maria-Schnee* altarpiece, I cannot share the unhesitating conviction of other Grünewald scholars that the *Virgin of Stuppach* belongs to the authentic Grünewald frame in the Maria-Schnee chapel of the Stiftskirche at Aschaffenburg, i.e. that it was executed in 1519—the date shown on the frame. Should this, however, be in fact true, then Plate 28 would be a drawing done in 1516–19. But for the time being, we must accept this date with reservations.

The case is again different for Plates 36 and 37. It is highly probable that both were preliminary studies for one of the three Grünewald altarpieces in Mainz Cathedral (always mentioned together in old literature), one of which was definitely dated 1520. This is borne out by an eyewitness account (by Sandrart) and an old inscription 'Menz' on the drawing, Plate 37. If the altarpieces were, as can be safely assumed, created around the same time, then one may consider that these two drawings, which form part of a *Glorification of the Virgin*, were also done about 1520. At least, this *Virgin* could not have been a drawing for 'stock', since it is typologically and iconographically unusual and suggests precise instructions from a patron.

If one is prepared to disregard these uncertainties (which had to be pointed out) and to accept them as possible certainties so as to gain a few fixed points, the following chronological order may be established:

about 1511 Studies for the Frankfurt *Transfiguration*. Plates 6–11.
about 1515 Studies for Isenheim altarpiece (undisputed). Plates 22–4, 27.
about 1519 Study for the *Madonna of Stuppach*. Plate 28.
about 1520 Studies for the Mainz *Glorification of the Virgin*. Plates 36–7.

This encompasses a period of ten years, with at least thirteen examples for purposes of comparison. If the dates are acceptable in each case, the next question will have to be: Is it possible to deduce from these fixed points a sequence of development into which we can incorporate drawings that cannot be dated by means of objective criteria?

The *Transfiguration* studies, about 1511, are technically and stylistically fairly homogeneous. They are characterized by a relatively broad, soft chalk stroke which is—for Grünewald—remarkably firm and resolute. The areas heightened with brushed-on white are opulent; the modelling is strong and clear; the shadows are solid and well defined, creating a pronouncedly plastic-painterly impression of a remarkably expansive bodily character. Drapery folds fall in broad lines. The feeling prevails, throughout

these drawings, that the artist was striving to create clear relationships. There is a lack of ornamental stylization and of excessive detail. Grünewald's drawings verge upon the style of Michelangelo's grand gesture; his characteristic fragile delicacy and imponderability are less in evidence here. In Plate 12—a *Virgin of the Annunciation* (Berlin)—we meet again a tendency to firm and sweeping lines, and a more objective graphic character which we noticed in the Frankfurt drawings, and here again, there is a feeling of vitality and liveliness. For reasons difficult to follow, this *Virgin of the Annunciation* is customarily connected with the somewhat later Isenheim altarpiece. The same tendency recurs in the *St. Dorothy* (Plate 13), which is regarded as a preliminary study for the lost *Glorification of the Virgin* for Mainz, probably dating from 1520. This theory seems to be supported by the setting of the *St. Dorothy*, yet is hardly confirmed by the figure itself which, realistically speaking, one simply cannot imagine as contemporaneous with the *Virgin* or the *Catherine* (Plates 36, 37) for the Mainz altarpieces, especially as the same degree of formal precision in the *St. Catherine* is achieved in the *St. Dorothy* with so much more subtlety and vitality. These qualities bring the *Dorothy* much closer to the Frankfurt drawings of the period around 1511 than to the Mainz ones of about 1520.

Between the Frankfurt drawings of the beginning of that decade—with, for Grünewald, surprisingly sweeping lines and robust firmness—and the brittle, delicate, almost timid drawings of Isenheim dating from the middle of the same decade, I believe we must place some other works the motifs of which point to Isenheim, although they have frequently been differently dated. In fact, only one detail from one single drawing has actually been used in the Isenheim altarpiece. These sheets are characterized as a whole by a more dense and robust, more coherent and slightly calligraphic style of draughtsmanship. They share these qualities with the Frankfurt drawings, but not with the actual Isenheim ones. The *Profile of an Old Man* (Plate 14) which Grünewald's biographers like to think is that of Guido Guersi, the patron who commissioned the Isenheim altarpiece, belongs to this group. We can certainly find proof of a connection between the Isenheim altarpiece and the three drawings of *Women Mourning* (Plates 15–20)—which are homogeneous in style—by the fact that one of them (Plate 19), wringing her hands in despair, has found her way into the figure of the fainting Virgin in the Isenheim *Crucifixion* (Fig. 5). There is no doubt that these four skilful drawings date from the first half of the second decade, i.e. the time of Grünewald's preparations for his masterpiece.

The *Portrait Head of a Woman* (Plate 21) in the Louvre is even closer in style to the Isenheim altarpiece than these other drawings. Another two definite Isenheim studies show great similarity in their timidly groping, surprised delicacy of line—the *St. Sebastian* (Plates 22, 23) and one of the two *Hermits* (Plate 24)—both in striking contrast to the robustness of the *Transfiguration* studies of a somewhat earlier period. There is a close relationship with the so-called *Self-Portrait* of Erlangen, which one must visualize in its original condition (Plate 27). These most delicate and reserved drawings are matched by the contemplative *Young Woman's Head* in Berlin (Plate 26). There is a much sharper contrast between the Isenheim studies and the second *Hermit* (Plate 25). Here, the lines are much firmer, the contours more definite, and the modelling stronger than in any of the other Isenheim studies, and at first glance reminiscent of the drawings for the *Transfiguration*. However, from a stylistic point of view, the example most closely related is the *St. Catherine* (Plate 36), which can be dated with considerable certainty about 1520. This strange fact is difficult to explain. On page 18, I suggested the possibility that somehow, Grünewald artificially stiffened the fabrics which he used on his models; this might account for the congealed hardness apparent in both the second *Hermit* and the *St. Catherine*. However,

there is another possibility for this surprising hardness of the graphic line: both the second *Hermit* and the female draped figure may not have been drawn from nature at all, but could have been copied from paintings. It is reasonable to suppose that Grünewald was tempted to repeat in another medium certain successful details from his paintings, and that he would be stimulated by the challenge presented, for example, by the difficult problem of reproducing folds and pleats in a drawing. If one accepts this hypothesis, the validity of the date 'about 1515' becomes doubtful; both the second *Hermit* and the *St. Catherine* could have originated c. 1520. If our reasoning is correct, earlier works were re-used by Grünewald in his later period, as was the case in the *Crucifixion* at Karlsruhe. We have here a completely natural process in an ageing artist whose powers are flagging, and whose objectives have shifted from the formal to the spiritual. The parallel cases of Titian, Handel, and even Bach, are well known.

Towards the end of the second decade, Grünewald shows unmistakable mannerist tendencies in his painting, as exemplified by the *Maria-Schnee* picture (Our Virgin of the Snows) at Freiburg, the frame of which, dated 1519, is still at the Maria-Schnee chapel of the Stiftskirche at Aschaffenburg. In this picture, Grünewald's style is clearer and more decisive than at any time before or afterwards. This enables us to assign to approximately the same period some of his most important drawings which can be described by the ambiguous epithet 'mannerist' and which accord with the style of the *Maria-Schnee* picture (Plates 29, 30, 32, 33, particularly 35, and perhaps even 28). To this group we must add some sheets where the style is less clearly defined but where the motif points to the same period (e.g. Plate 28).

The drawings made probably during his last period (Plates 36–42) are as little consistent in style as those presumed to date from his early period (Plates 1–5). This is quite natural, since each group occupies a space of just under a decade, i.e. as much time as the four other groups together. The same substantial differences must be expected in the latter.

And yet, we find in his last period even greater vacillation within a narrow space of time. If it is true that Plates 36–41 are, in fact, related to the lost Mainz altarpieces, apparently dating from about 1520, then we are here confronted with differing qualities of style in close succession, i.e.: soft dissolution (Plates 37, 38), stiff rigidity (Plate 36), realistic detail (Plates 39, 40), broad flowing lines (Plate 37) and comparative triviality (Plate 36). One may be tempted to regard these vacillations as symptoms of a flagging creative self-assurance, together with a certain coarsening, which one must, in all honesty, also recognize in his late paintings (e.g. the Passion pictures of Karlsruhe). And yet this would not be true for Grünewald the *draughtsman*. If the *Head of a Screaming Figure* (Plate 41)—its difficult perspective mastered with the astonishing touch of genius—is to be dated about 1520 (as is usually assumed, probably with justification), then the expressive *Prelate's Head* (Plate 42) must be assumed to be at least contemporaneous if not later. And in that case, Grünewald the draughtsman would have reached an incontestable summit. A happy idea, which would be immediately negated if, as is often done, the *Head of an Old Woman* (Louvre, Plate 49) were accepted as coming from Grünewald's own hand—a head which has not been mastered to the full.

With all these reservations made, we can sketch Grünewald's development as a draughtsman between about 1505 and about 1520 roughly as follows:

1. *Earliest drawings:* before 1510. Side by side with delicate 'Gothic' elements, we find a more realistic formal conception, preference being given to broad, heavy strokes and well-detailed modelling, with some scumbling of the hatching strokes. Examples: Plates 1 and 5.

2. *Works of his early maturity:* about 1510. Energetic, patently discernible control of lines. Strong contrasts of light and shade which create an impression of compact plasticity. The painterly device of heightening with white is employed with a certain bravura. In the general flow of lines, Grünewald now tends to a bold simplification. Folds are frequently treated as straight-running tubes; breaks in folds are emphatically angular. Examples: Plates 6–11.

3. *Works of the period of second maturity:* about 1515. General refinement of graphic means of expression. Conscious adoption of a style close to nature, expressed in a sensitive, hesitant, brittle line; in the *valeurs* an irregularly patchy total effect. Calligraphy and ornamentality are largely abandoned. Examples: Plates 20–4, 26–7.

4. *Mannerist echoes:* about 1519. Clearest example: the *Male Nude* (Plate 35), which comes close to international mannerism both in its proportions and in the graphic style.

5. *Last drawings:* about 1520. Side by side with masterly depth, there appear signs of the relaxed freedom of genius. Examples: Plates 37–8. On occasion, entire figures are covered with a dense web of strokes, resulting in patterns of nuances and structures rather than modelling (Plate 36, even 25).

★ ★ ★

Grünewald's graphic works were obviously valued and preserved, right from the beginning. This is expressly confirmed by Joachim von Sandrart:

'It is now 50 years since a very old but accomplished painter lived at Frankfurt, his name being Philipp Uffenbach, having at one time been apprenticed to the famous German painter Grimer; this said Grimer was a pupil of Matthaeus of Aschaffenburg, and whatever he was able to collect of his works, has diligently kept; particularly after his master's death he obtained from the latter's widow a number of magnificent sketches, mostly in black chalk, and some of them almost life-size. After Grimer's decease, the above Philipp Uffenbach, being a famous, thoughtful man, took possession of all this. At that time I went to school not far from his house, and often attended upon him where-upon—if he was in good humour—he would show me these noble drawings of Matthaeus of Aschaffenburg, collected into a book. He would carefully study their manner and point out their laudable qualities and beauty. After the same Uffenbach's death, his widow sold this whole book at a good price to the renowned art lover, Herr Abraham Schelkens of Frankfurt, and the latter placed it in his famed art cabinet, to the eternal memory of this illustrious hand, and for the sweet edification of all art lovers, and I would direct the well-disposed reader to it.'

PLATES

Where a caption is preceded by an asterisk, the reproduction is in the same size as the original.

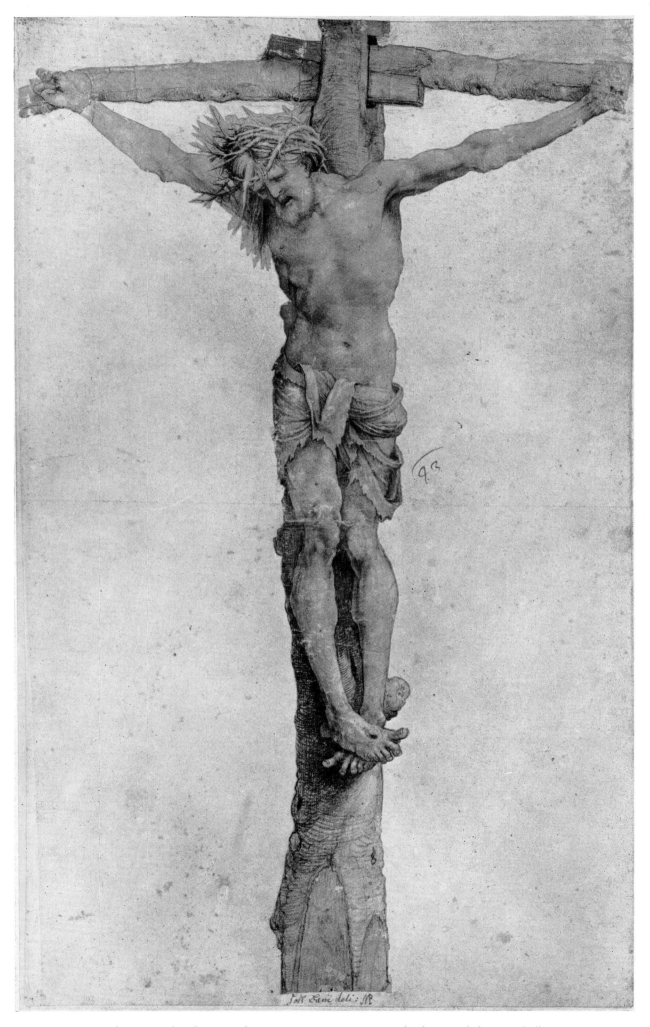

1 (Cat. no. 1). Christ on the Cross. 531 × 320 mm. *Karlsruhe, Staatliche Kunsthalle*

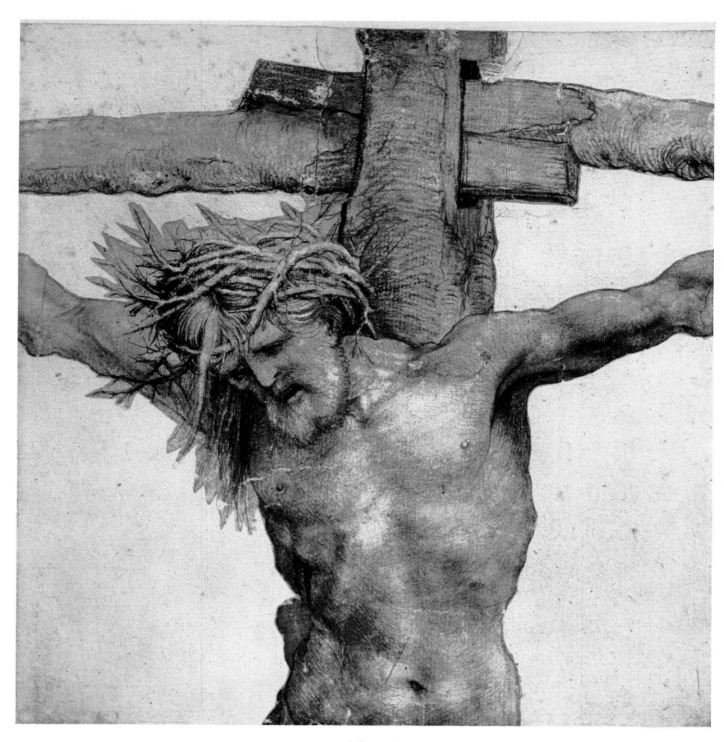

* 2. Detail from plate 1

* 3 (Cat. no. III). Drapery Study. 130×180 mm. *Northampton, Mass., Smith College Museum of Art*

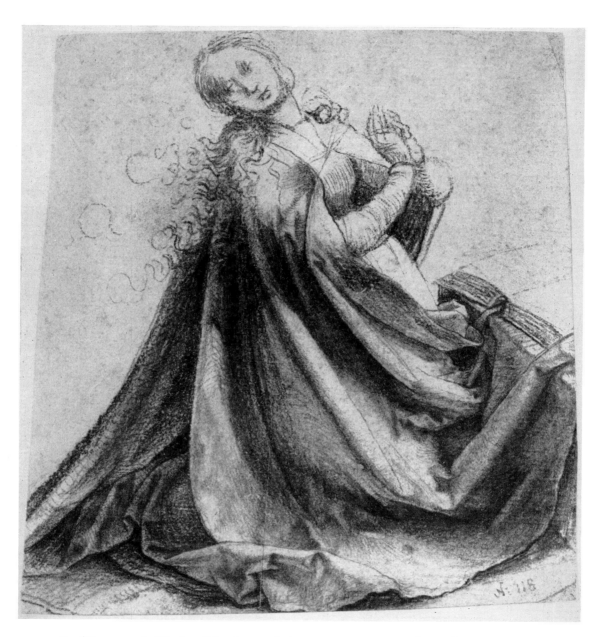

* 4 (Cat. no. IV). Virgin of the Annunciation. 160 × 146 mm. *Berlin-Dahlem, Print Room*

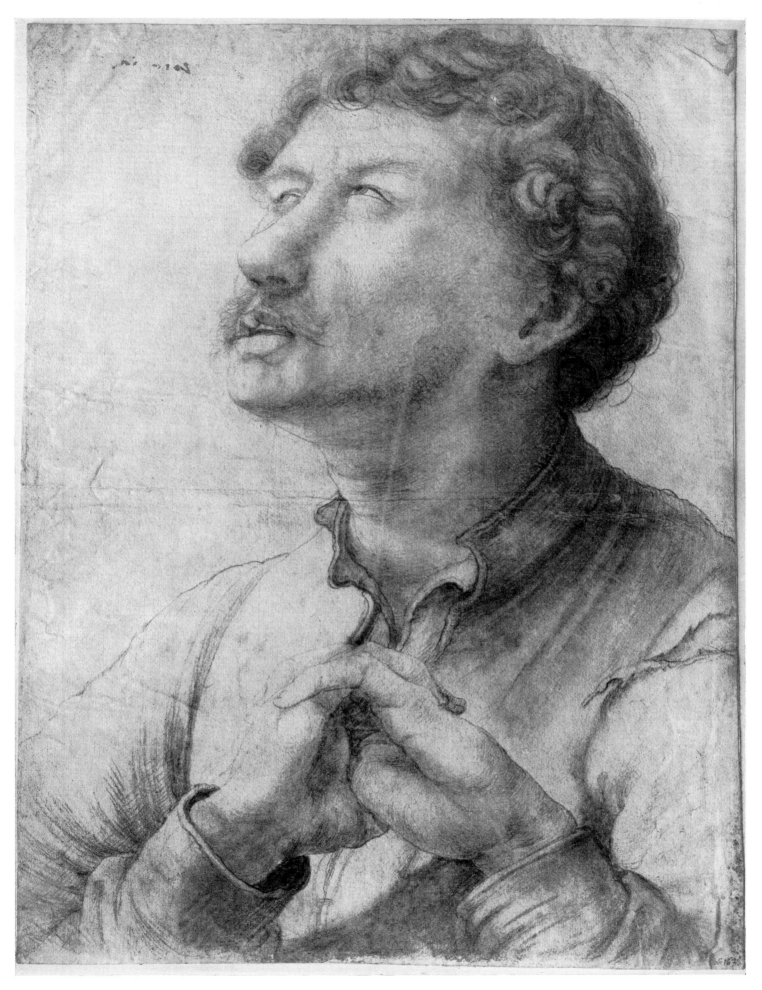

5 (Cat. no. II). Young man clasping his hands (St. John). 434×320 mm. *Berlin–Dahlem, Print Room*

* 6 (Cat. no. v). Falling man seen from the back. 146×208 mm. *Dresden, Print Room*

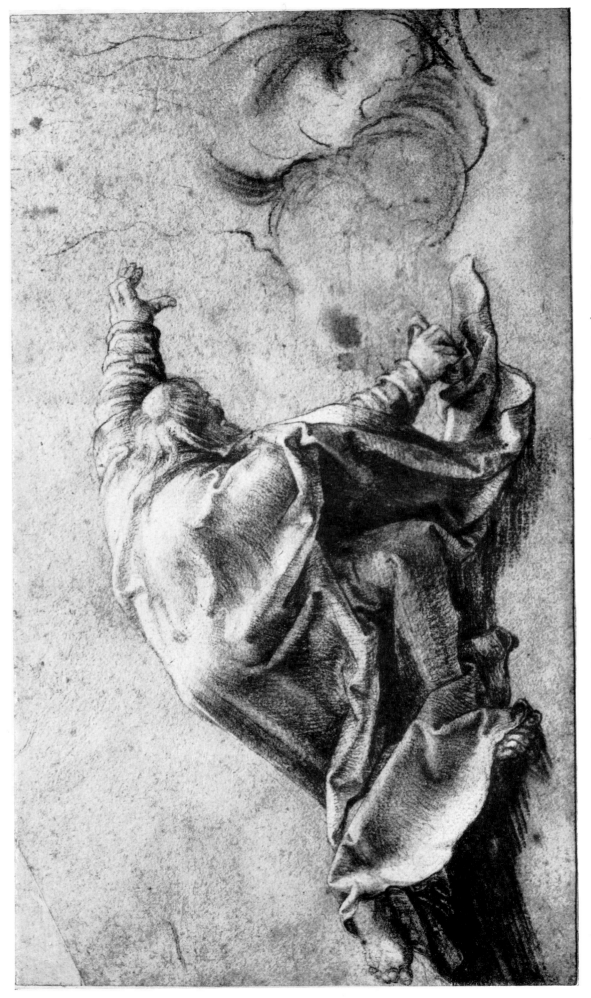

* 7 (Cat. no. VI). Falling man seen from the side (St. Peter). 148×267 mm. *Dresden, Print Room*

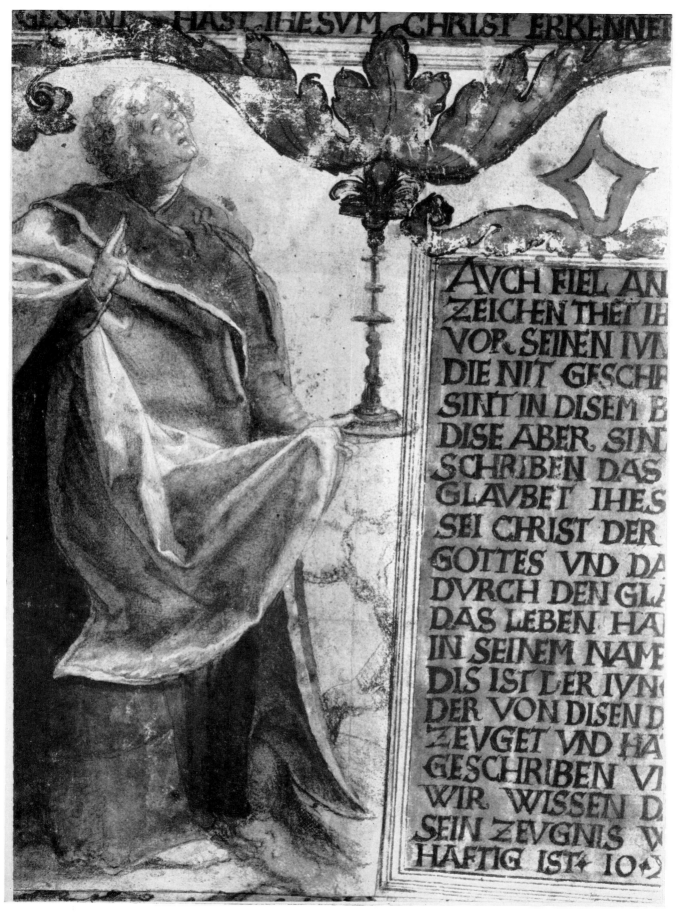

* 8 (Cat. no. VIII). Young man standing, his right hand raised in blessing (St. John the Evangelist). 244 × 118 mm.
Berlin (East), Print Room

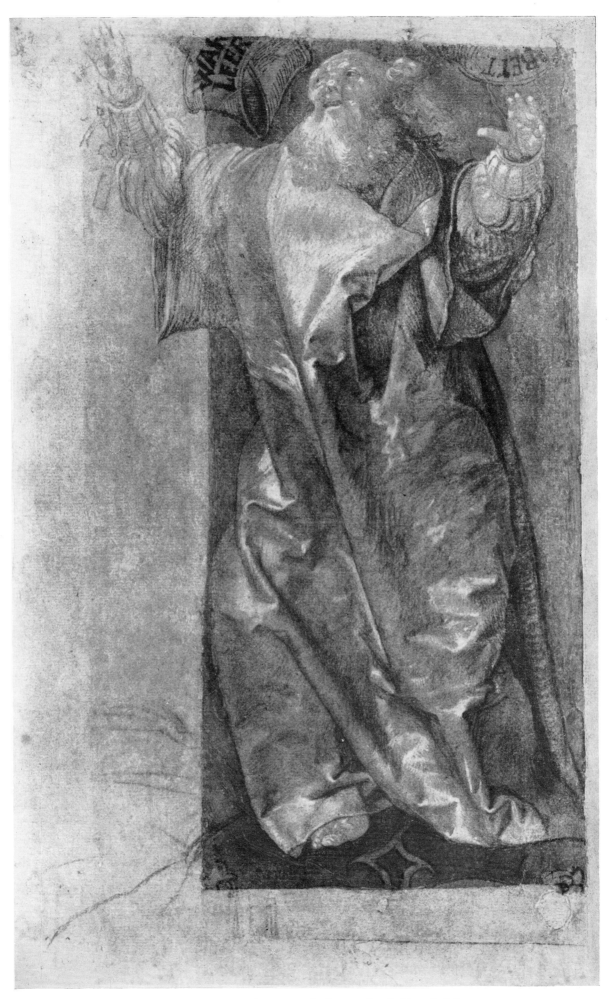

9 (Cat. no. VII). Man running, with outstretched arms (probably Christ). 324×181 mm.
Berlin (East), Print Room

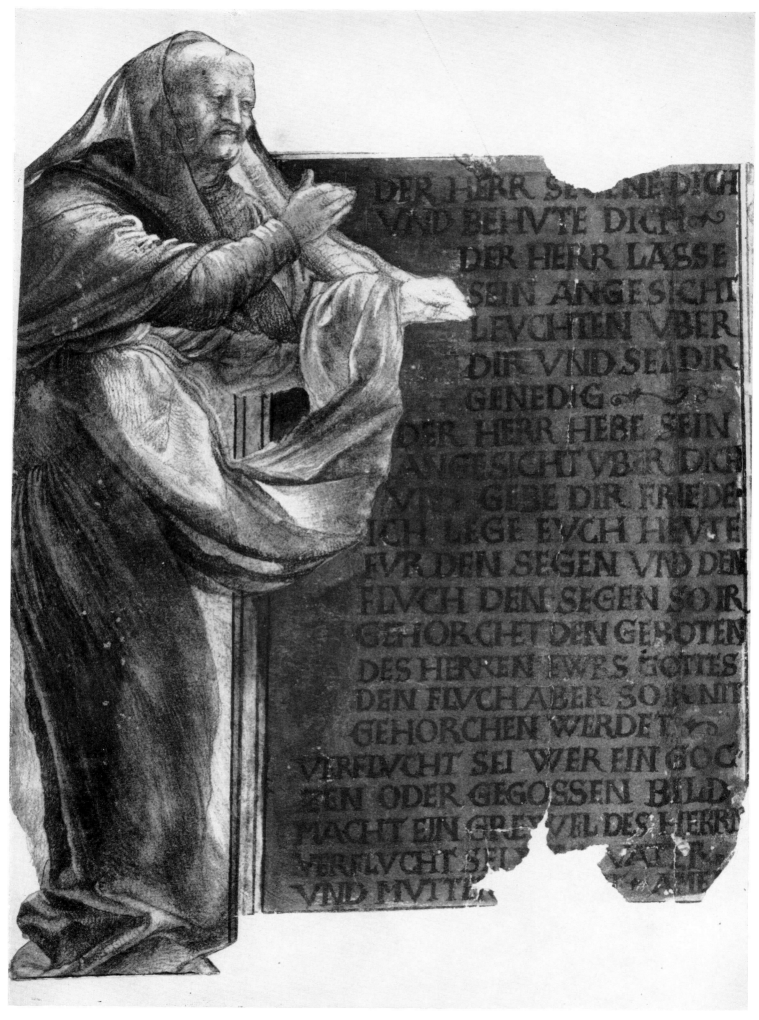

10 (Cat. no. IX). Bearded man standing (Moses or Aron). 280×129 mm. *Berlin (East), Print Room*

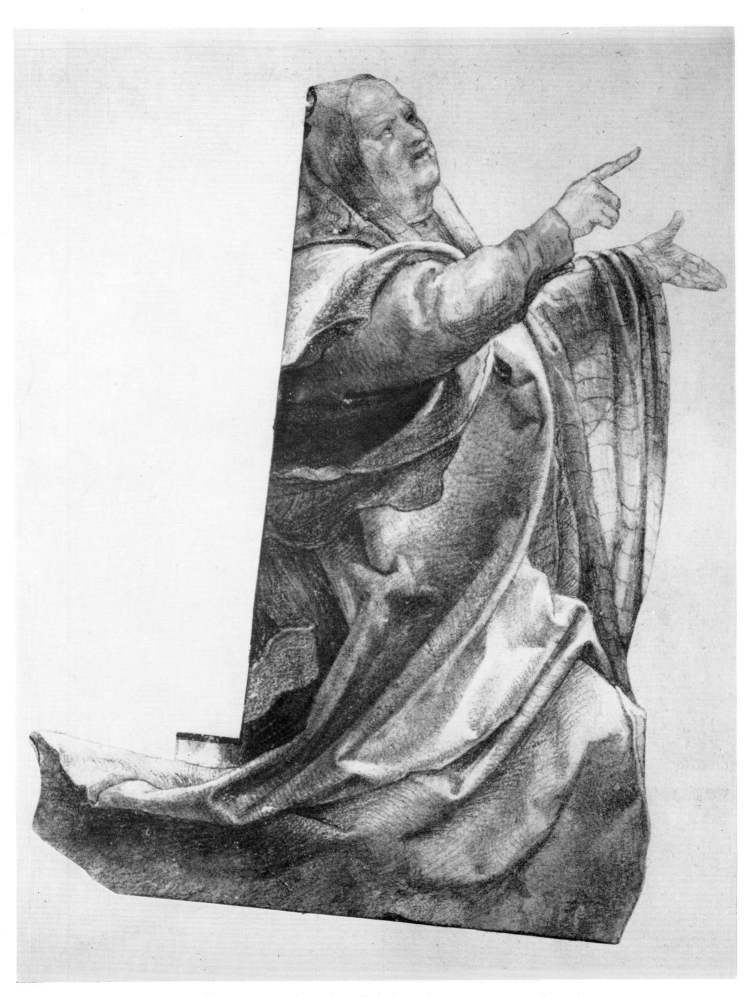

11 (Cat. no. x). Kneeling man gesticulating (so-called Pharisee). 348 × 214 mm. *Berlin–Dahlem, Print Room*

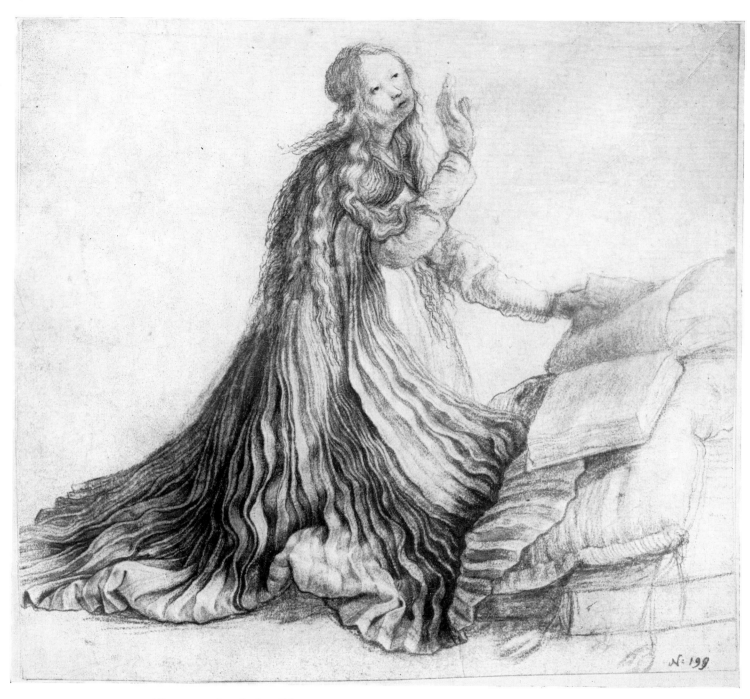

12 (Cat. no. XII). Virgin of the Annunciation. 207×210 mm. *Berlin-Dahlem, Print Room*

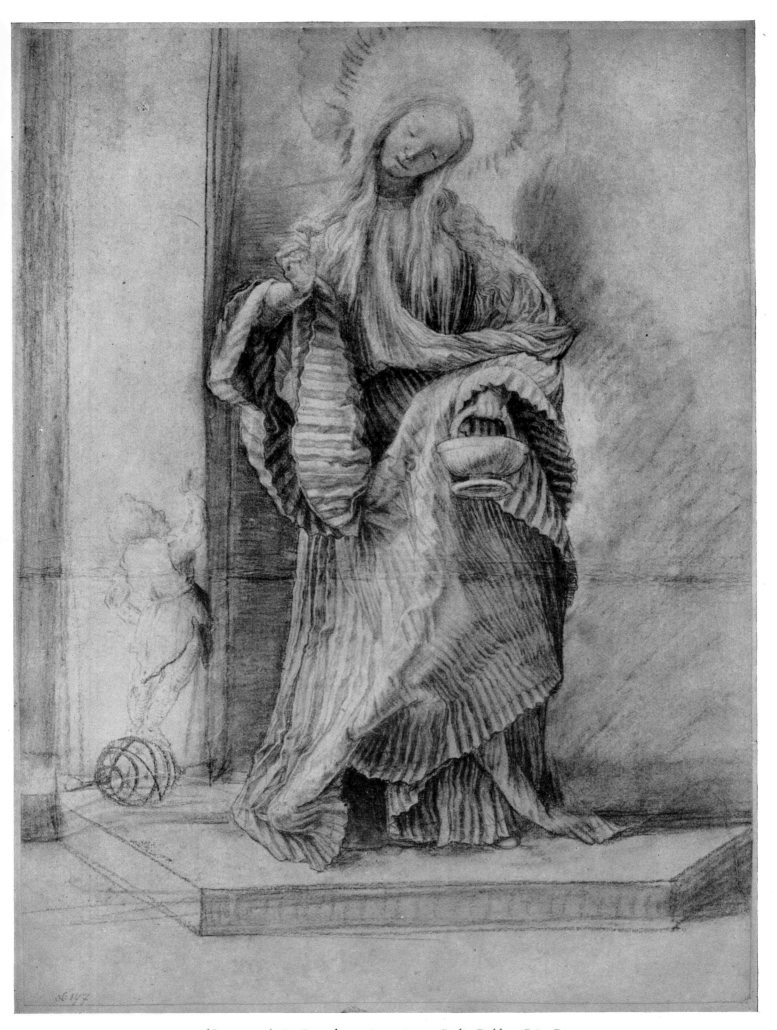

13 (Cat. no. XI). St. Dorothy. 358×256 mm. *Berlin-Dahlem, Print Room*

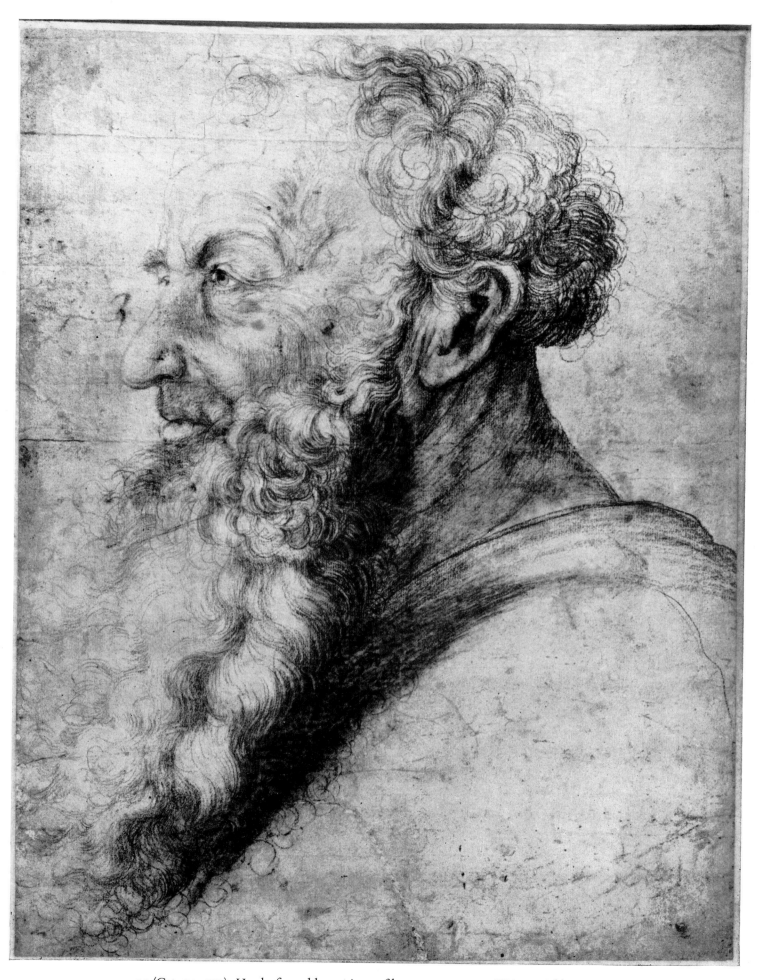

14 (Cat. no. XIII). Head of an old man in profile. 341×253 mm. *Weimar, Schlossmuseum*

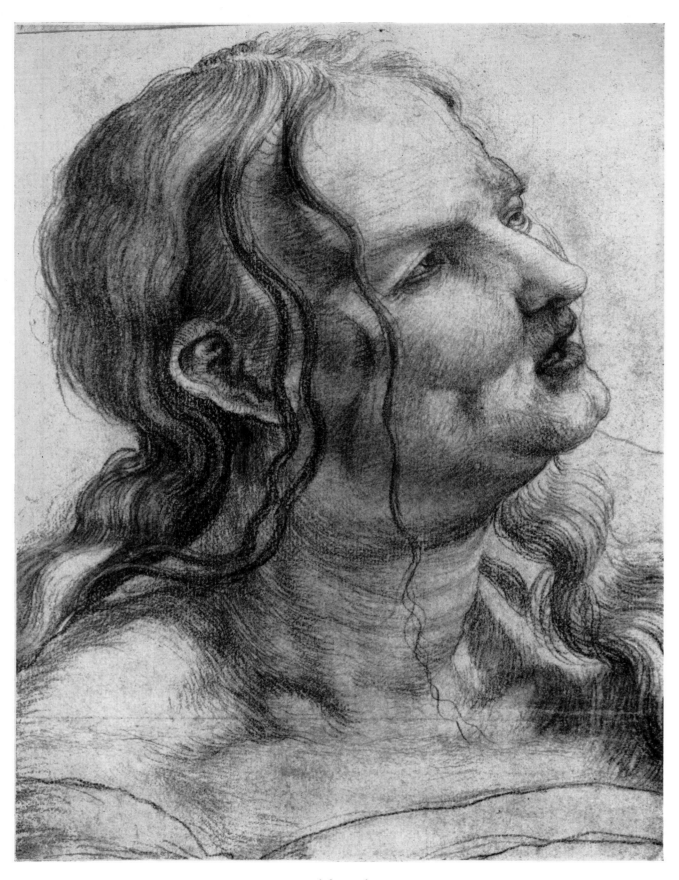

* 15 Detail from plate 16

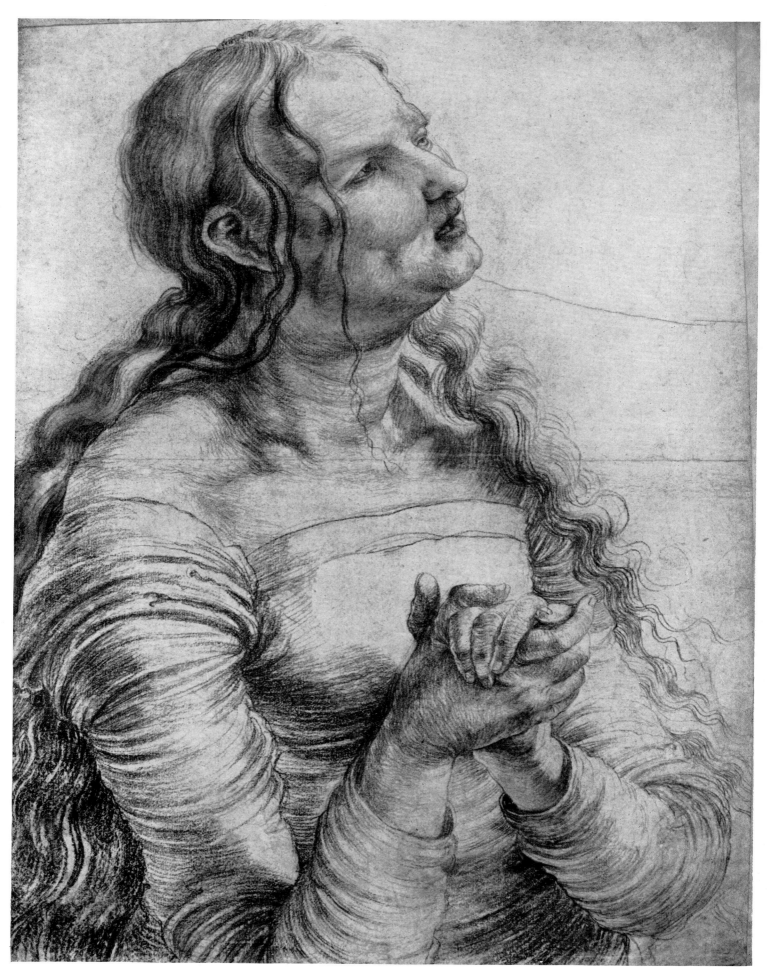

16 (Cat. no. xv). Half-length of a mourning woman. 410×300 mm. *Winterthur, Oskar Reinhart Foundation*

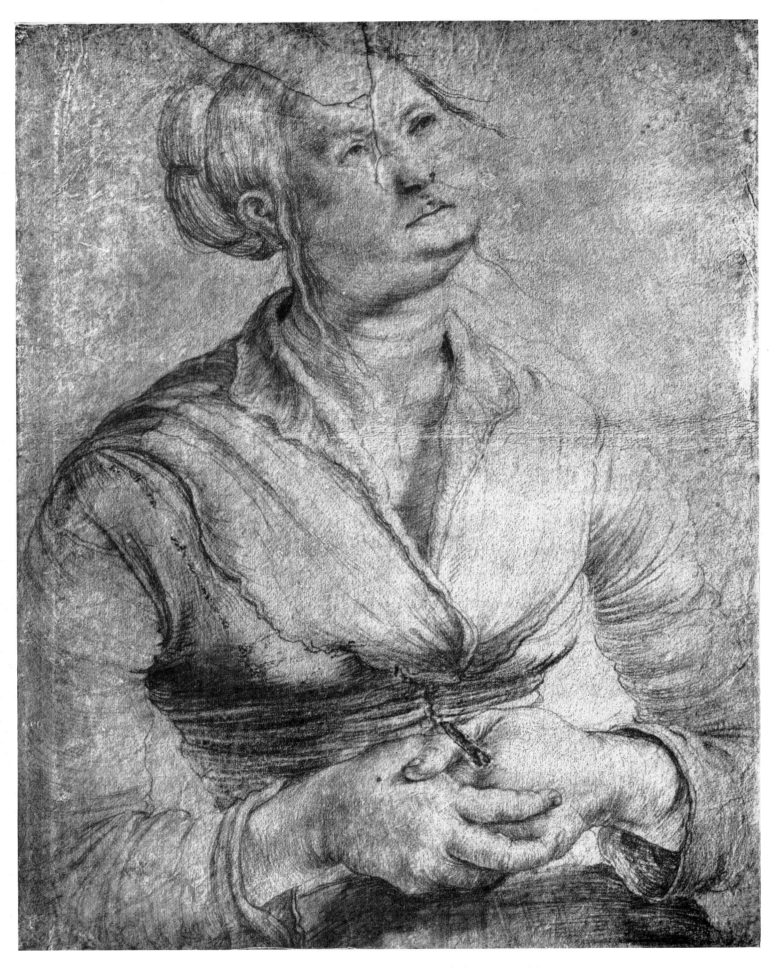

17 (Cat. no. XIV). Half-length of a woman looking upwards (Mary Magdalen?). 384×283 mm.
Formerly Lützschena near Leipzig, Speck zu Sternburg Collection

* 18. Detail from plate 17

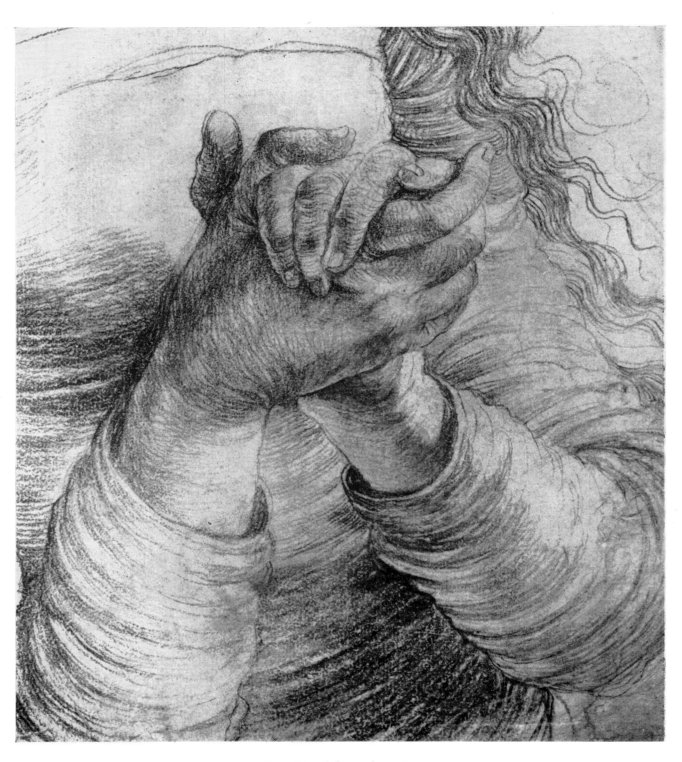

* 19. Detail from plate 16

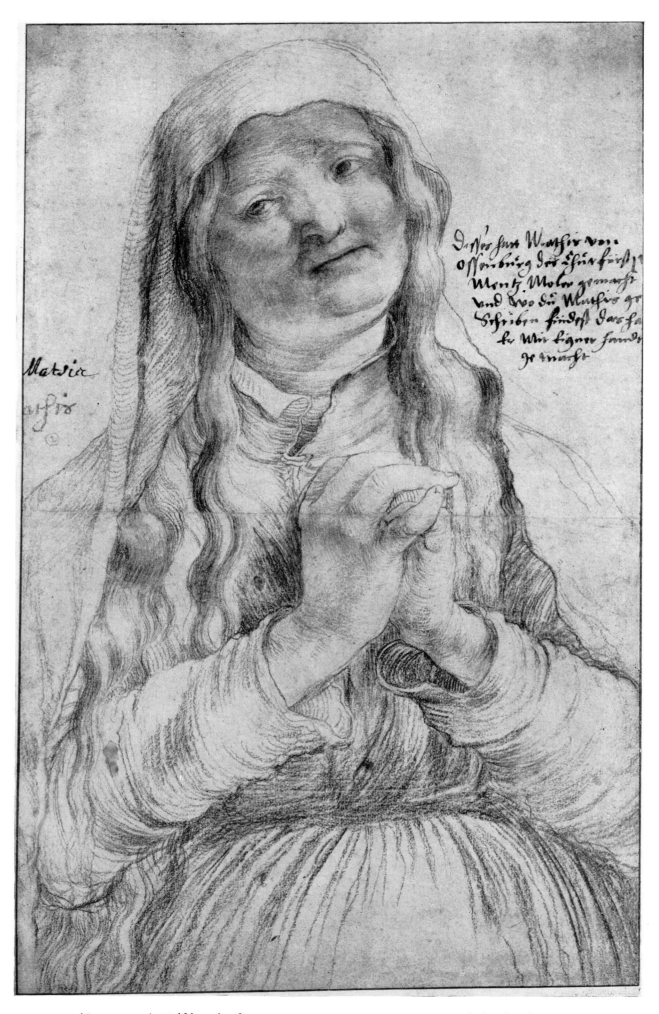

20 (Cat. no. XVI). Half-length of a mourning woman. 380×240 mm. *Oxford, Ashmolean Museum*

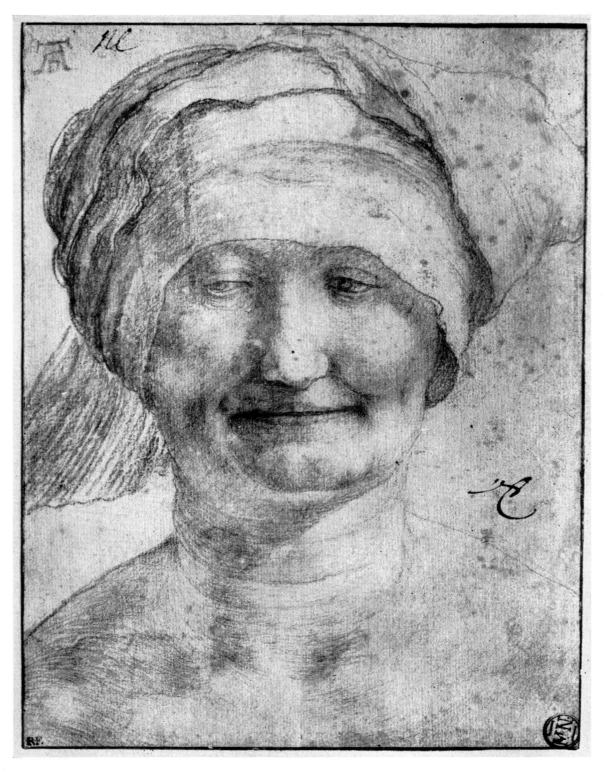

* 21 (Cat. no. XVII). Head of a woman. 201 × 147 mm. *Paris, Louvre, Cabinet des Dessins*

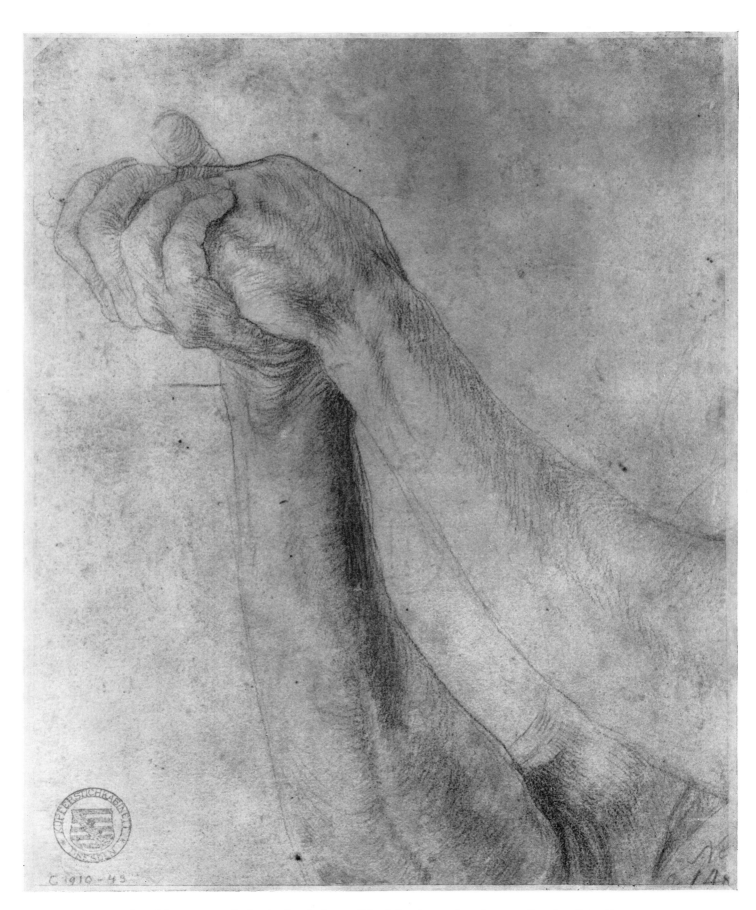

* 22 (Cat. no. XVIII). Study for the bust of St. Sebastian. 238×189 mm. *Dresden, Print Room*

* 23 (Cat. no. XIX). Study for the bust of St. Sebastian. 289×203 mm. *Berlin (East), Print Room*

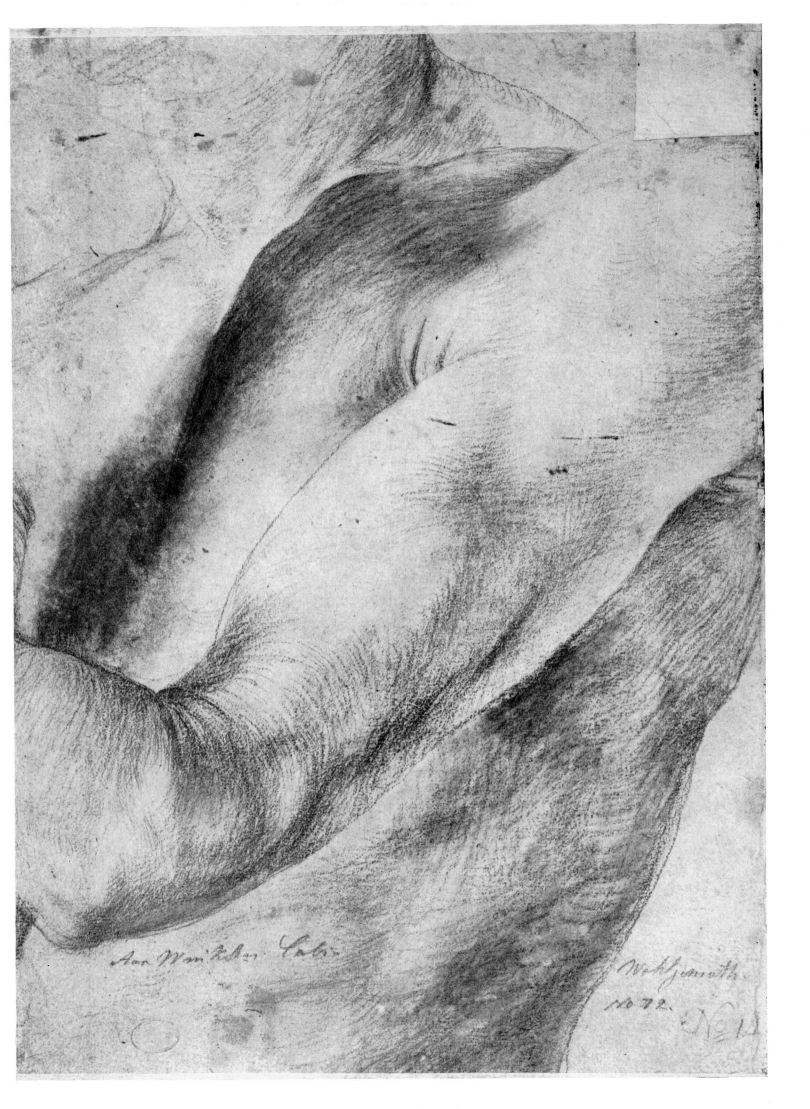

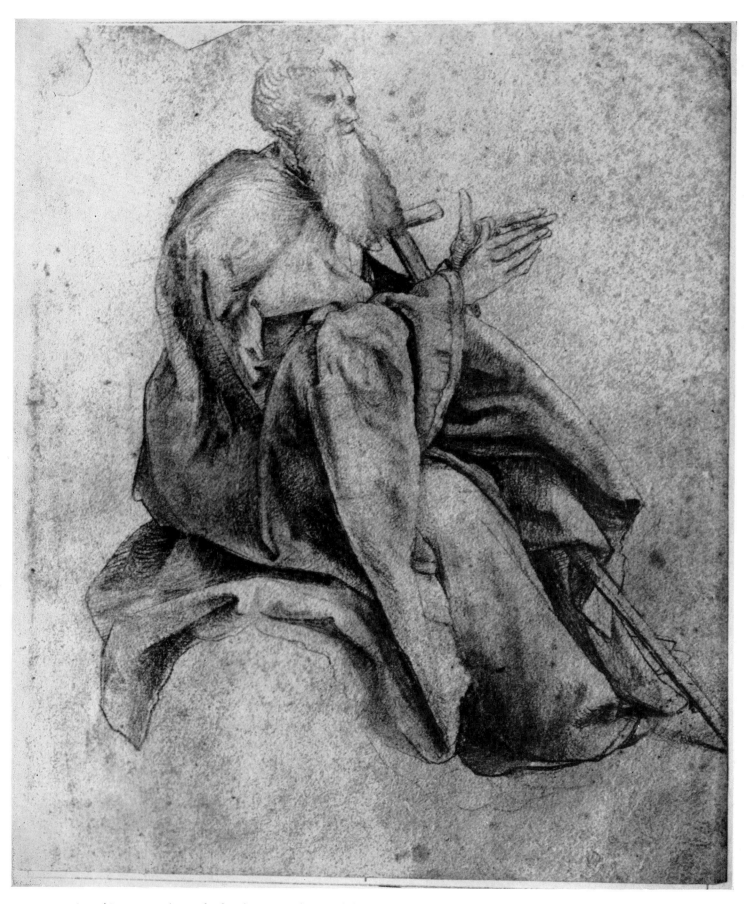

* 24 (Cat. no. **xx**). Study for the St. Anthony of the Isenheim altar-piece. 238 × 189 mm. *Dresden, Print Room*

* 25 (Cat. no. xxi). St. Anthony. 289 × 202 mm. *Berlin (East), Print Room*

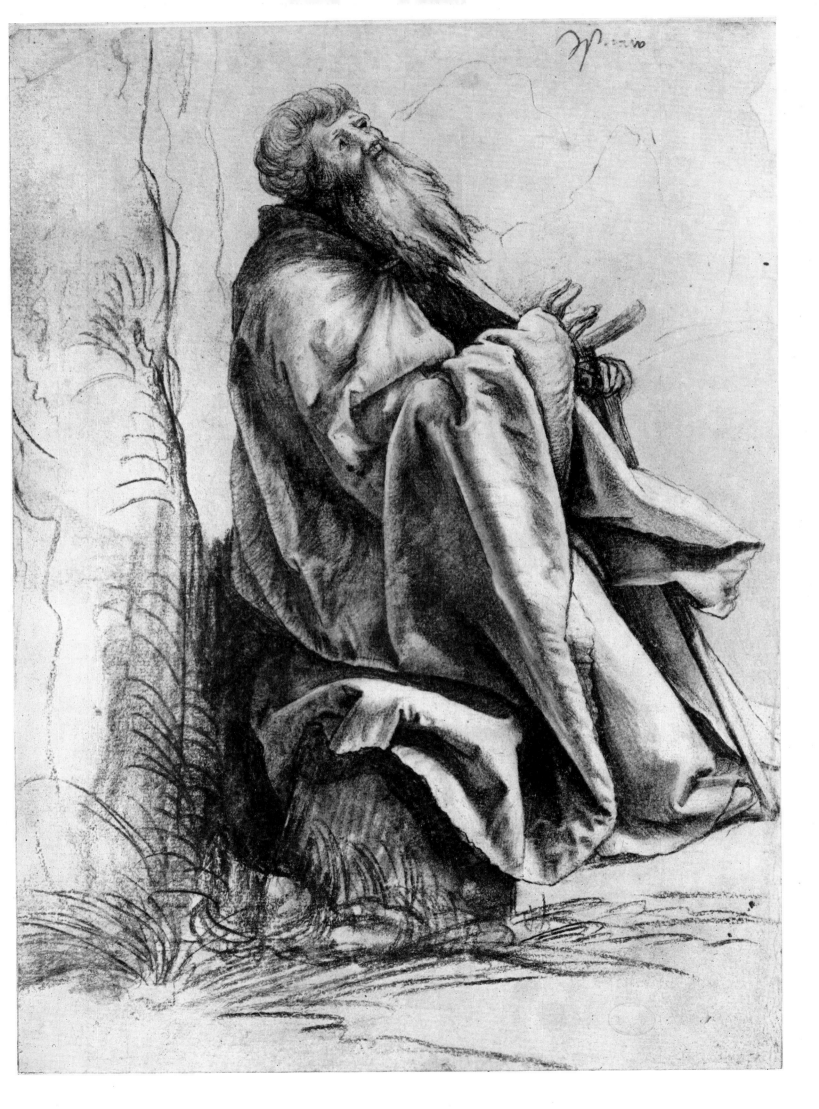

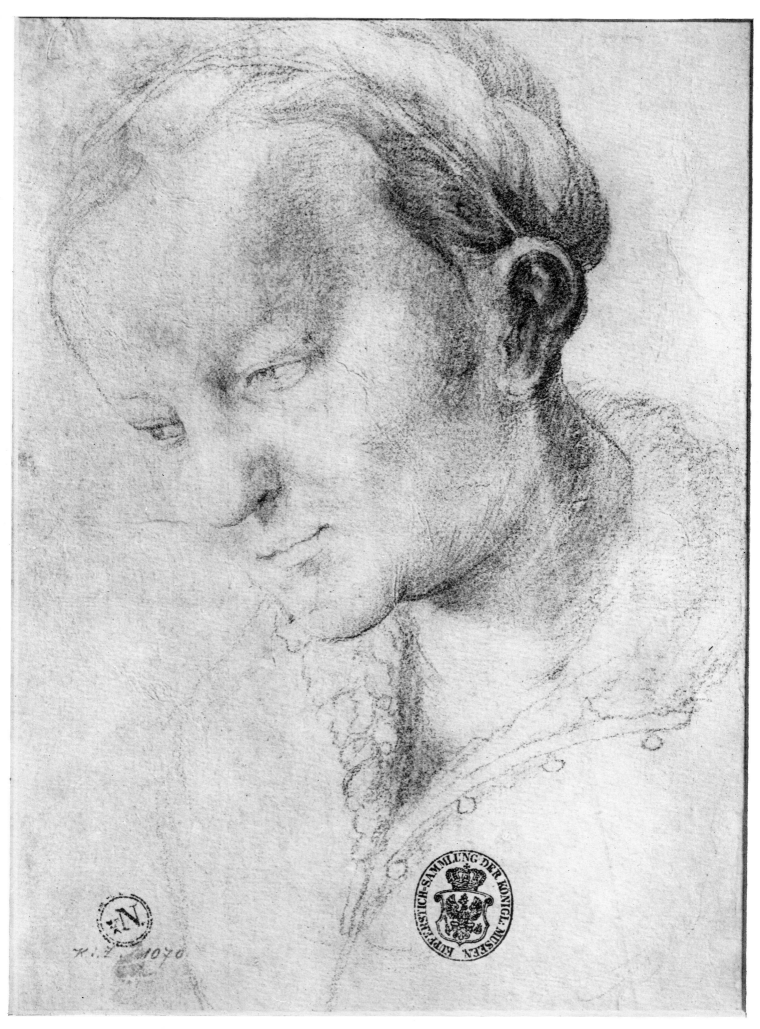

* 26 (Cat. no. XXIII). Head of a young woman. 277×196 mm. *Berlin-Dahlem, Print Room*

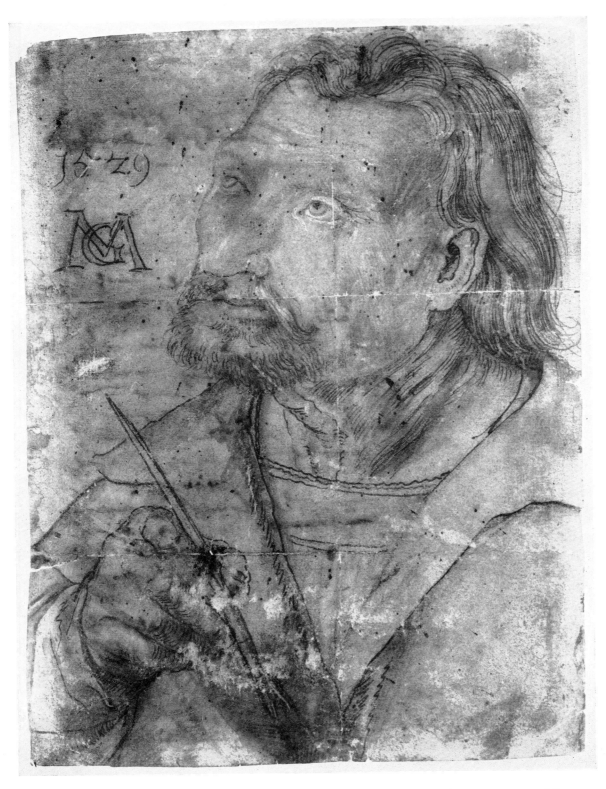

* 27 (Cat. no. XXII). So-called self-portrait of Grünewald. 206 × 152 mm. *Erlangen, University Library*

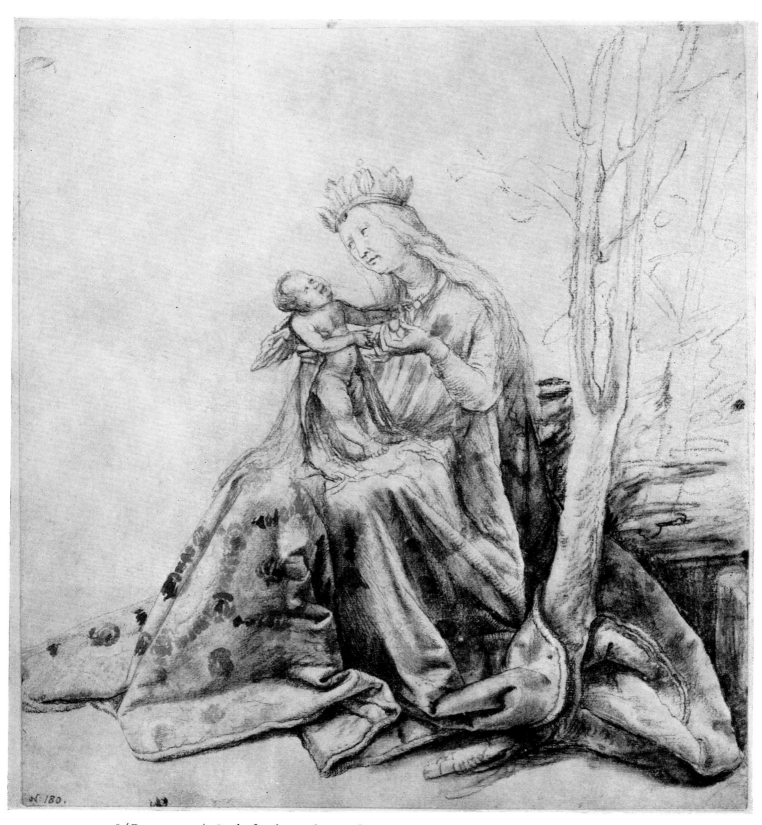

28 (Cat. no. XXIV). Study for the Madonna of Stuppach. 314×278 mm. *Berlin-Dahlem, Print Room*

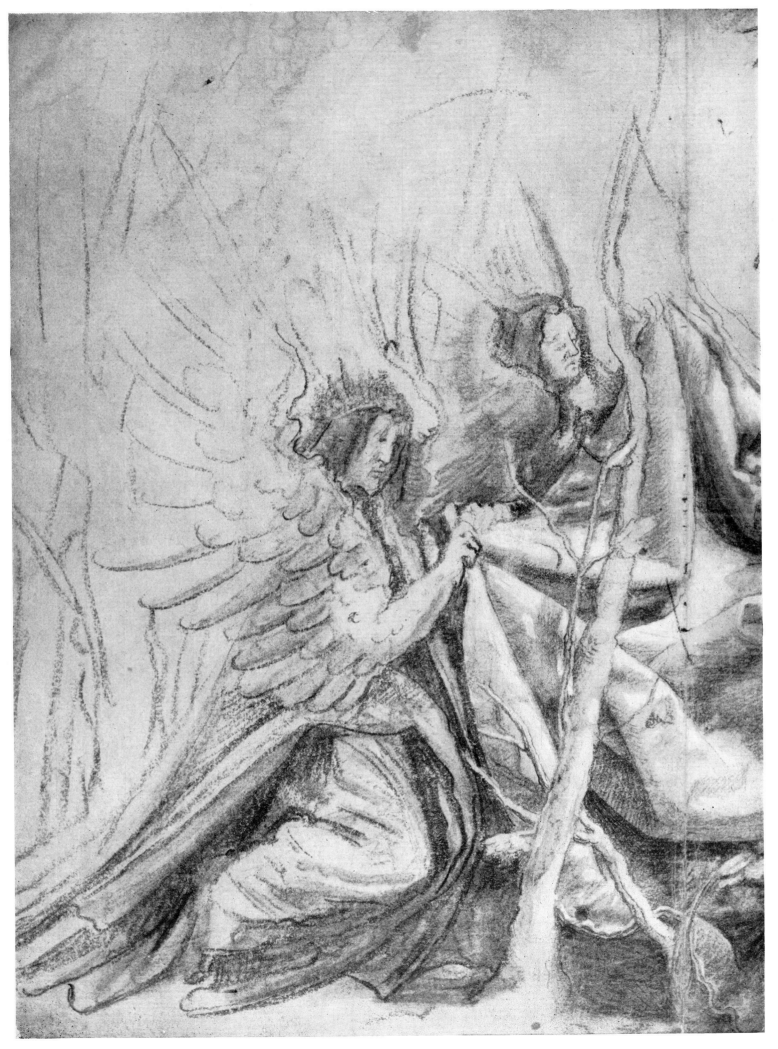

* 29. Detail from plate 30

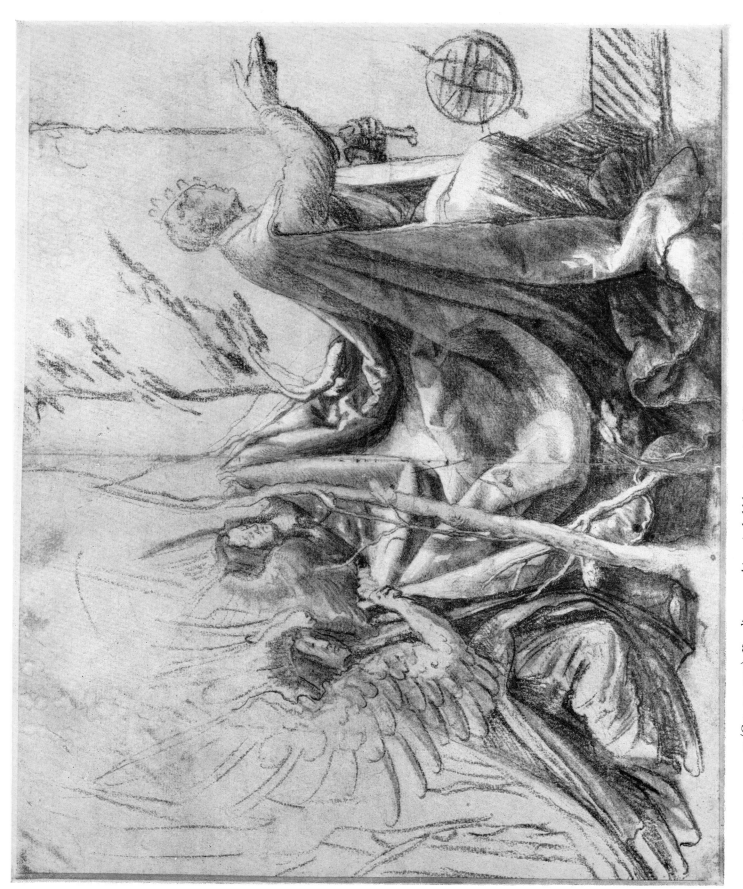

30 (Cat. no. xxv). Kneeling man, his train held by two winged figures. 286 × 366 mm. *Berlin–Dahlem, Print Room*

31 (Cat. no. xxvii). St. Peter. 368 × 296 mm. *Vienna, Albertina*

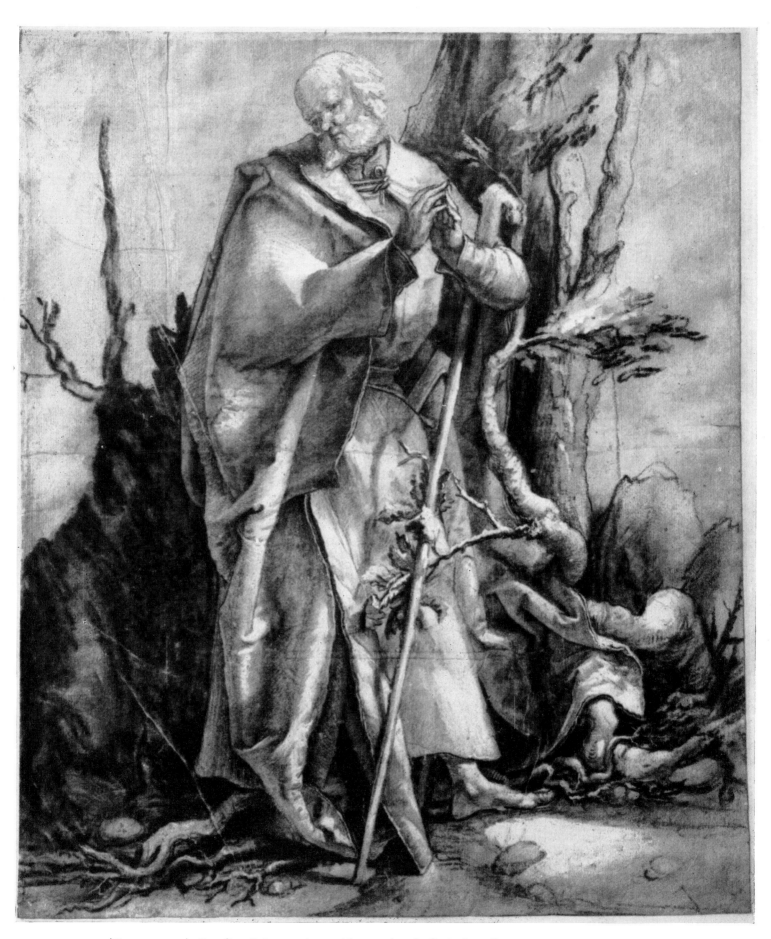

32 (Cat. no. XXVI). Standing Saint praying, with sword and pilgrim's staff. 368 × 296 mm. *Vienna, Albertina*

33 (Cat. no. XXVIII). Virgin and Child with St. John. 286 × 366 mm. *Berlin-Dahlem, Print Room*

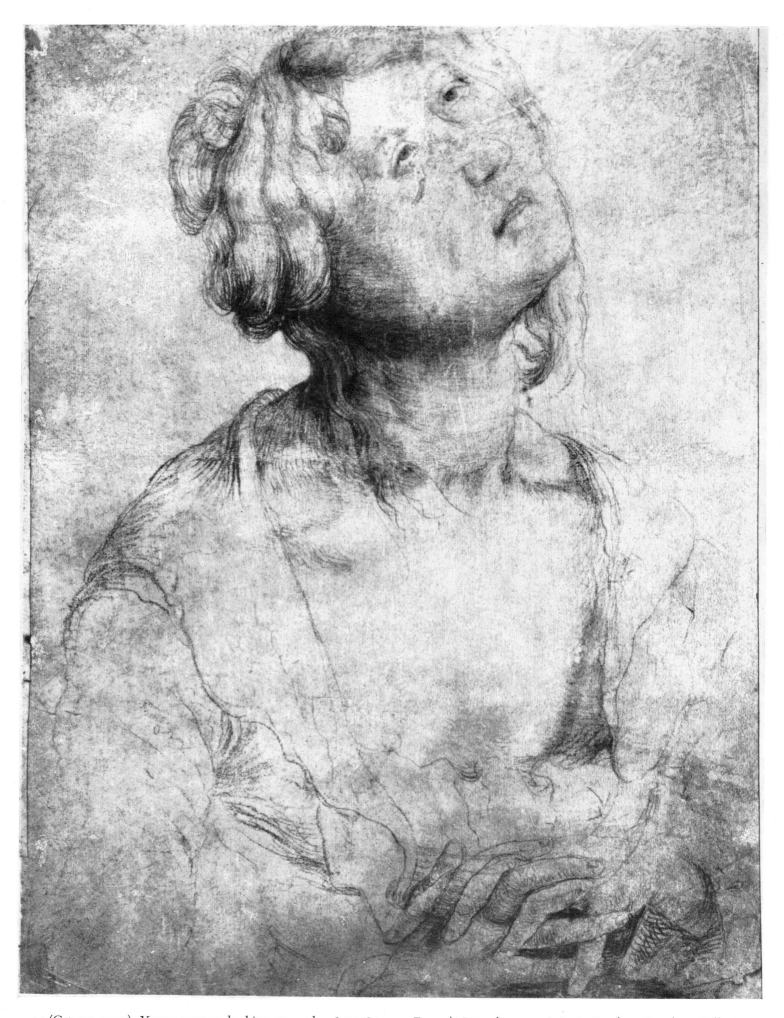

34 (Cat. no. XXIX). Young woman looking upwards. 384×283 mm. *Formerly Lützschena near Leipzig, Speck zu Sternburg Collection*

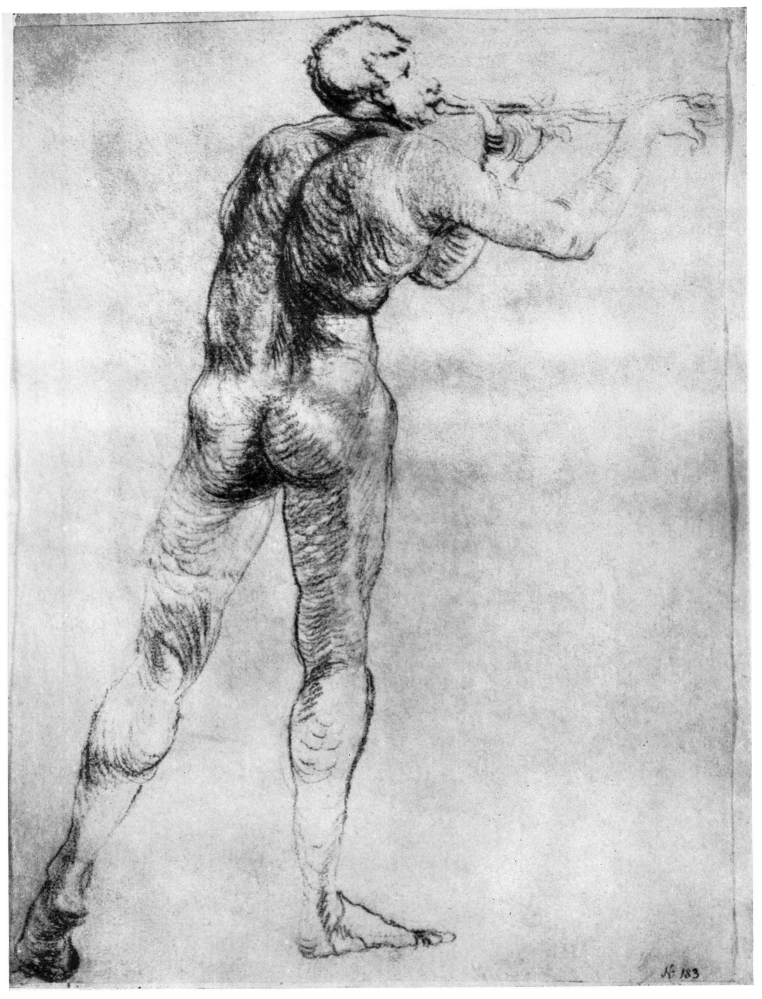

*35 (Cat. no. xxx). Nude flute-player. 271×195 mm. *Formerly Haarlem, F. Koenigs Collection*

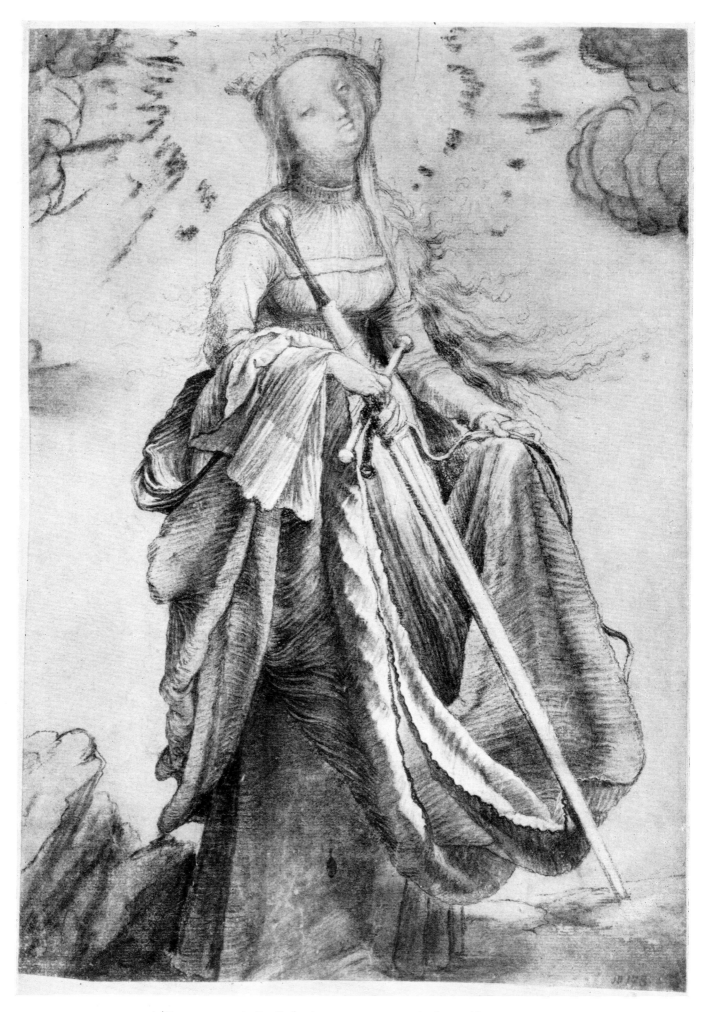

36 (Cat. no. XXXII). St. Catherine. 316 × 215 mm. *Berlin-Dahlem, Print Room*

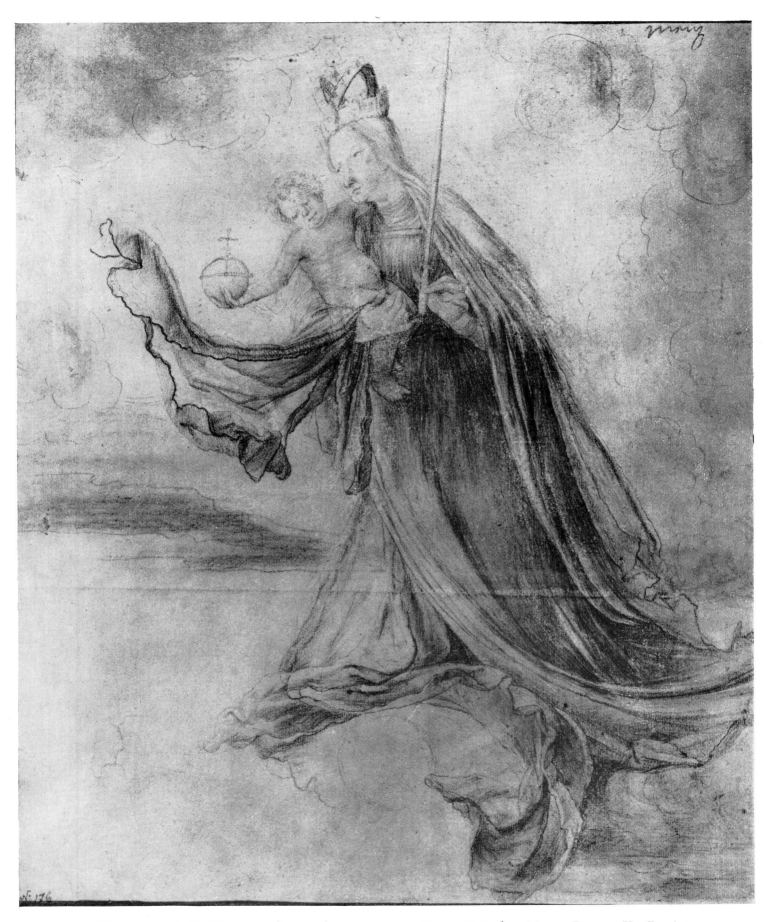

37 (Cat. no. **XXXI**). The Virgin standing on the moon. 325 × 268 mm. *Rotterdam, Museum Boymans-Van Beuningen*

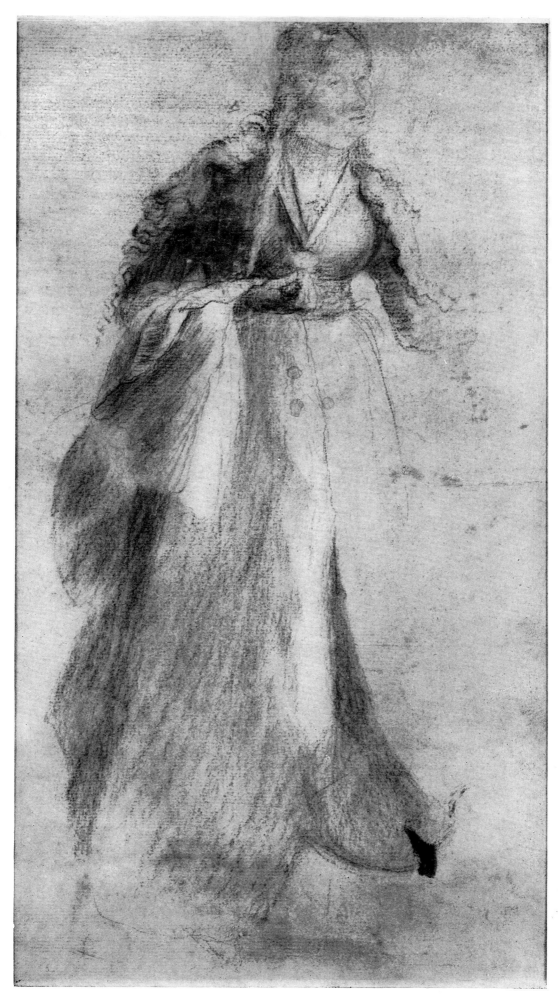

38 (Cat. no. XXXIII). Female saint. 316×215 mm. *Berlin–Dahlem, Print Room*

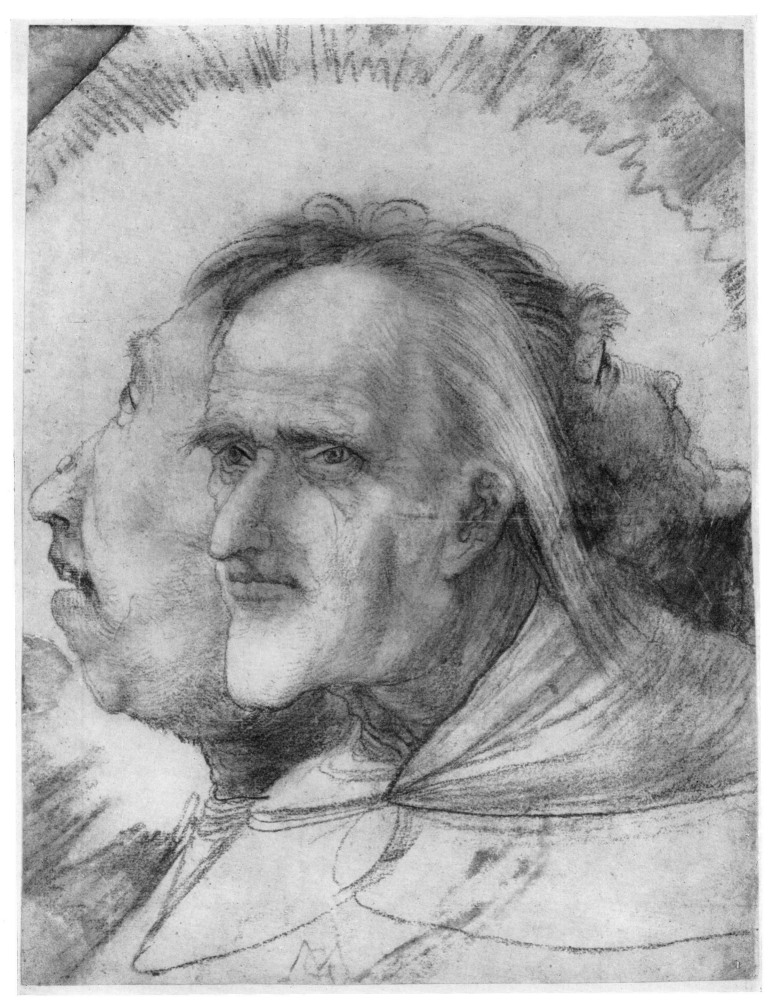

* 39 (Cat. no. XXXIV). Trias Romana. 272×199 mm. *Berlin-Dahlem, Print Room*

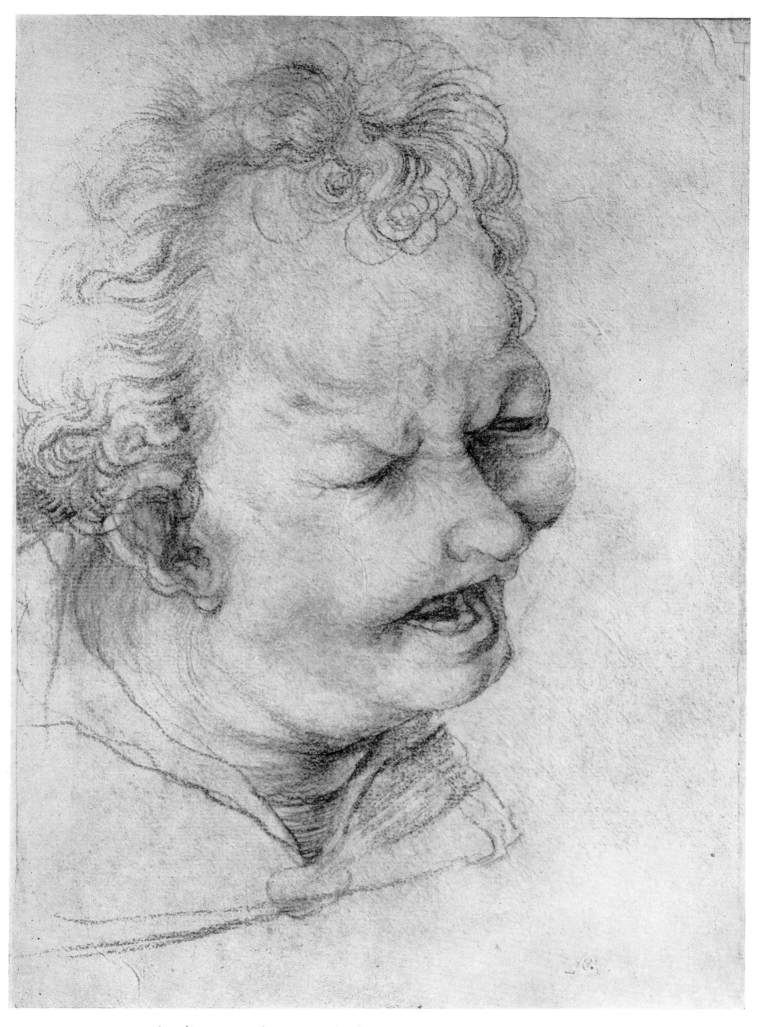

* 40 (Cat no. xxxv). Screaming head. 276×196 mm. *Berlin-Dahlem, Print Room*

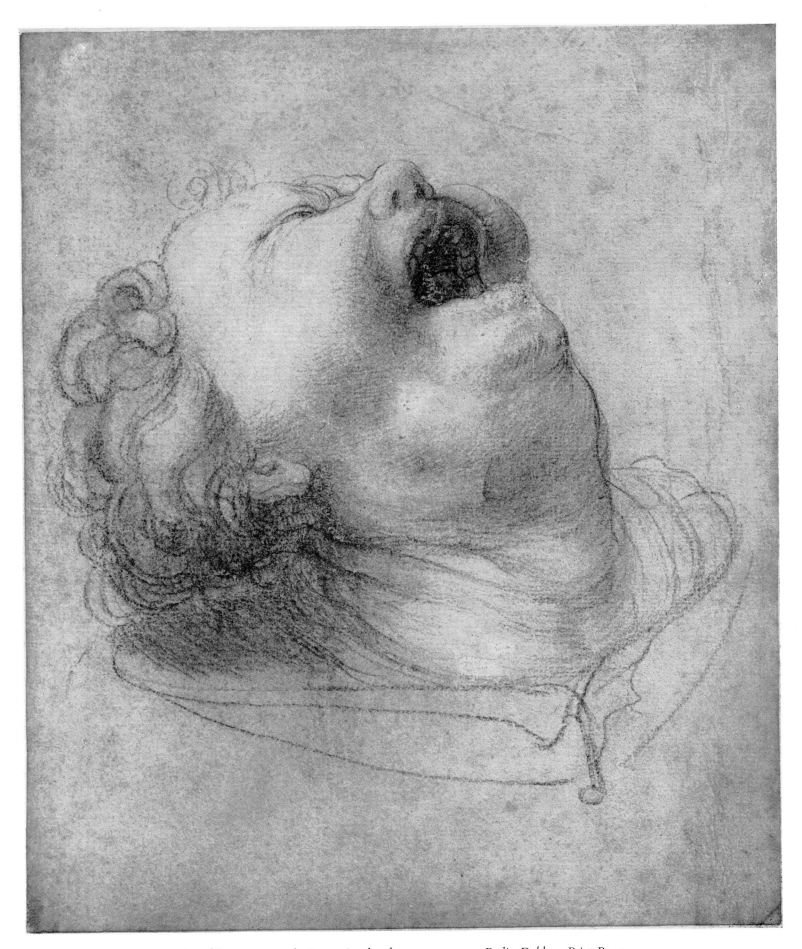

* 41 (Cat. no. XXXVI). Screaming head. 244 × 200 mm. *Berlin-Dahlem, Print Room*

* 42 (Cat. no. xxxvii). Head of a beardless old man. 255 × 190 mm. *Stockholm, National Museum*

APPENDIX

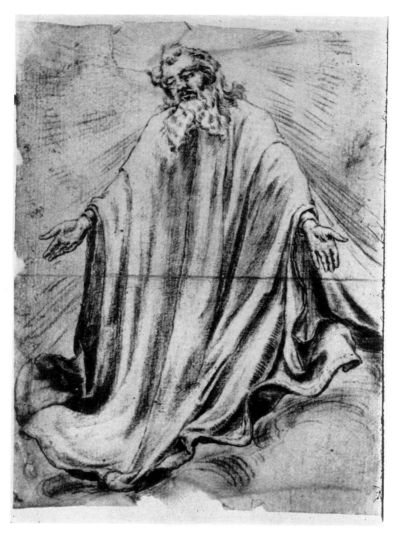

43 (Appendix: a). God the Father. 310×230 mm. *Private collection*

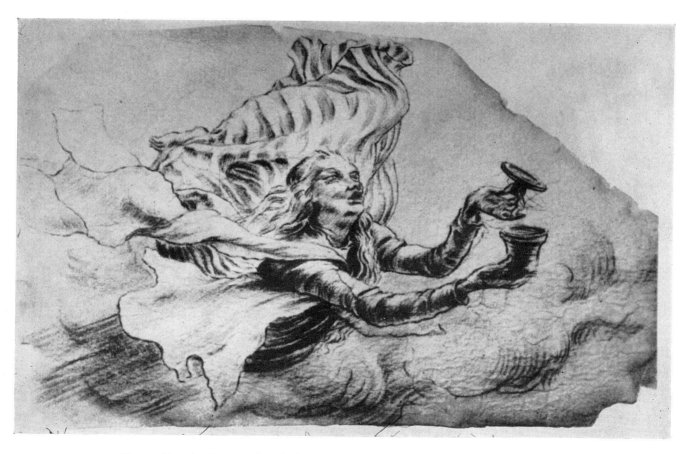

44 (Appendix: c). Floating female figure, opening a jar. 142×230 mm. *Private collection*

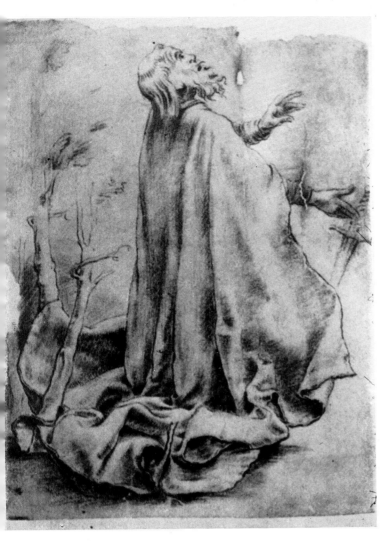

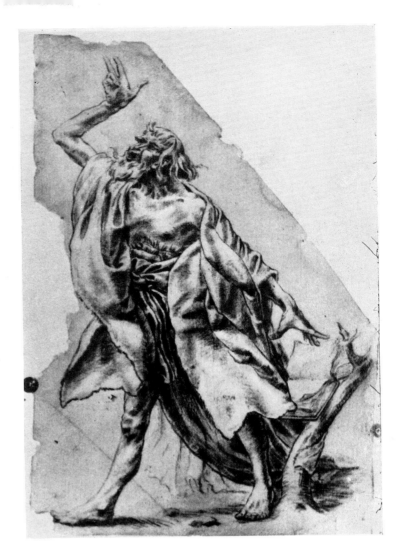

45 (Appendix: f). St. Paul. 273×205 mm. *Private collection* 46 (Appendix: e). St. John the Baptist preaching. 308×204 mm. *Private collection*

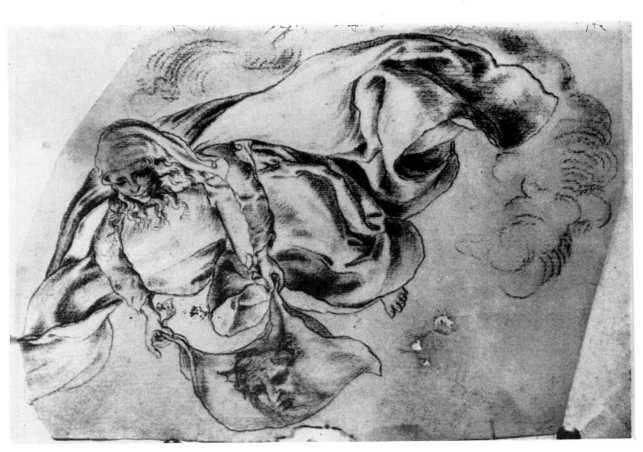

47 (Appendix: d). Floating female figure with the sudary of St. Veronica. 190×270 mm. *Private collection*

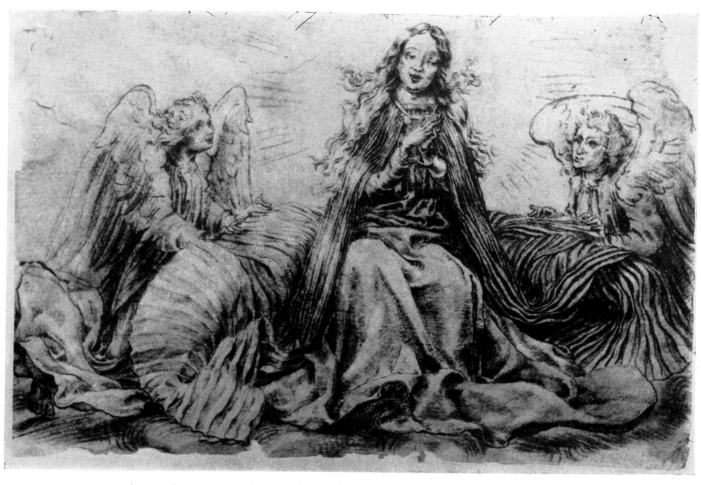

48 (Appendix: b). The Virgin with train bearing angels. 320 × 350 mm. *Private collection*

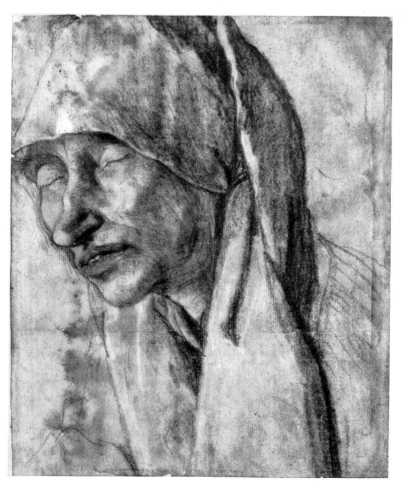

49 (Appendix: g). Head of Margarete Prellwitz. 288 × 224 mm.
Paris, Louvre, Cabinet des Dessins

50. Christ. (Anonymous copy of plate 9). *Berlin (East), Print Room*

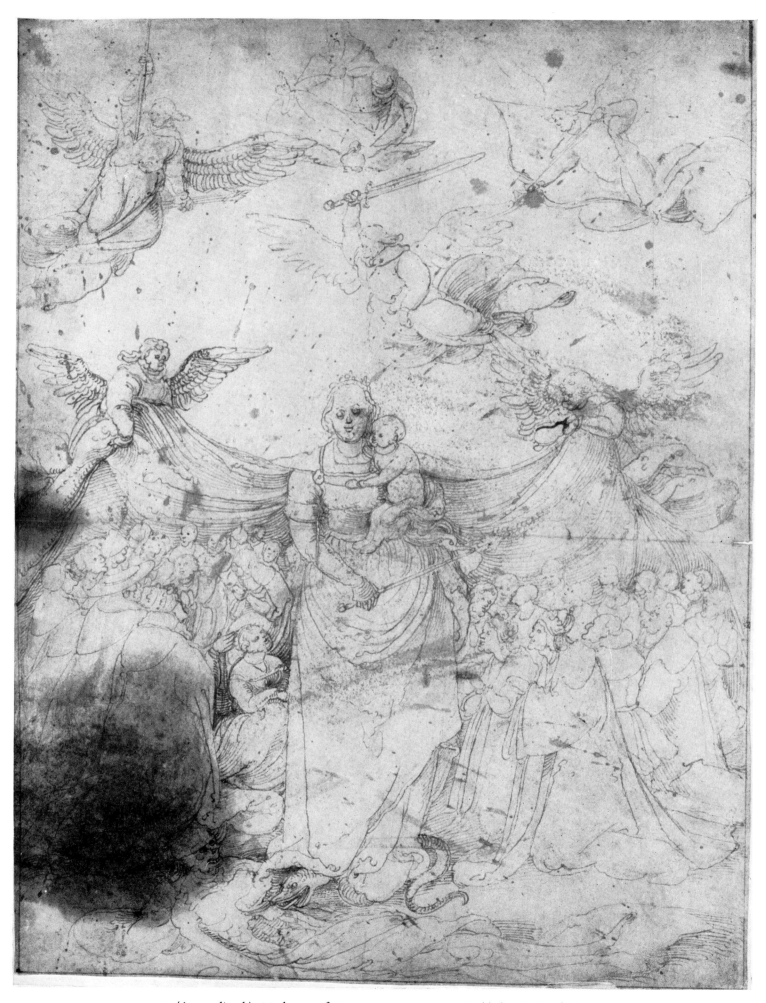

51. (Appendix: h). Madonna of Mercy. 315×234 mm. *Stockholm, National Museum*

CATALOGUE

BIBLIOGRAPHY

The most complete list of literature on Grünewald as draughtsman is to be found in Lottlisa Behling's work *Die Handzeichnungen des Mathis Gothart Nithart genannt Grünewald*, Weimar, 1955, pp. 123–6. As that book is generally obtainable there is no need to repeat her bibliography in full. In the Catalogue section of the present book, reference is made, as appropriate, to articles dealing with particular aspects of Grünewald's drawings. In the following list, I mention only those books which, in my opinion, are the most important in dealing with Grünewald's draughtsmanship. This list also contains monographs which include his paintings:

Schmid, H. A., *Die Gemälde und Zeichnungen von Matthias Grünewald*, vol. 2, Strasbourg, 1911.

Hagen, O., *Matthias Grünewald*. Munich, 1919.

Storck, W. F., *Handzeichnungen Grünewalds*. First publication of the *Gesellschaft für zeichnende Künste*. Munich, 1922.

Friedländer, M. J., *Die Zeichnungen von Matthias Grünewald*. Berlin, 1927.

Feurstein, H., *Matthias Grünewald*. Bonn, 1930.

Burkhard, A., *Matthias Grünewald, Personality and Accomplishment*. Cambridge, 1936.

Fraenger, W., *Matthias Grünewald, ein physiognomischer Versuch*. Berlin, 1936.

Graul, R., *Grünewalds Zeichnungen*. Leipzig, 1937.

Zülch, W. K., *Der historische Grünewald*. Munich, 1938.

Schönberger, G., *The Drawings of Mathis Gothart Nithart called Grünewald*. New York, 1948.

Holzinger, E., *Zur Datierung der Grünewaldzeichnungen*. Beiträge für Georg Swarzenski. Berlin, 1951, pp. 129 ff.

Behling, L., *Die Handzeichnungen des Mathis Gothart Nithart genannt Grünewald*. Weimar, 1955.

CATALOGUE

I

CHRIST ON THE CROSS (Plates 1, 2)

Chalk, heightened with white; 20⅞ × 12⅝ in.; 53·1 × 32 cm.
(The figure has been cut out and stuck on a new sheet of paper.)
Staatliche Kunsthalle, Karlsruhe (acquired from Basle).

This drawing, of which there is a more complete copy measuring 21⅝ × 15⅜ in. (55 × 39 cm.) in the Öffentliche Kunstsammlung, Basle (Zülch, *Der historische Grünewald*, Munich, 1938, Plate 168), undoubtedly comes closest to the *Christ on the Cross between the Virgin and St. John* (Fig. 1) at Karlsruhe, although it is true that in the painting Grünewald did not follow the drawing literally. There are some noticeable differences: in the drawing, the hands (not completely preserved) are clenched, while in the painting they are open. The loin-cloth also differs considerably both in the centre and at the left; finally, the feet are crossed in the drawing, while they are parallel in the painting. However, the position of the feet shown in the drawing recurs in the Basle *Crucifixion*, though nowhere else. Apart from these deviations, however, the drawing resembles the Christ in the Karlsruhe painting to such an extent that one may assume it served as a free model for the latter. The body type shows similarities. Position and expression of the head are almost identical, except that in the painting it has dropped even lower. In the drawing, the figure appears thinner, but this might be due in part to the fact that it was cut out. The question is whether the drawn and the painted versions date from the same period. The paintings at Karlsruhe are probably the latest extant paintings from Grünewald's hand, and must be dated later than 1525 (cf. Ruhmer, *Matthias Grünewald, The Paintings*, London, 1958, p. 127). On the other hand, this is the most painstakingly detailed of the Grünewald drawings known to us. When directly compared with the painting, it strikes an almost medieval note. We can safely assume that the drawing was done much earlier than the painting; it was probably part of an ever-ready stock of sheets which he kept in reserve for future paintings, while not feeling bound to adhere slavishly to every detail.
Indeed, recent research regards the Karlsruhe drawing as the earliest extant (cf. Lottlisa Behling, *Die Handzeichnungen*

des Mathis Nithart, genannt Grünewald, Weimar 1955, pp. 22 ff., 94; and other literature mentioned there). It is usually dated shortly before or after 1503, i.e. contemporaneous with the *Mocking of Christ* (Pinakothek, Munich), which, incidentally, contains a similar fleshy, bearded Christ. It must be agreed, therefore, that this drawing at Karlsruhe is one of the artist's early works, although we lack concrete evidence to pinpoint the date more precisely.
While the modern critic is in no doubt as to the authorship of the drawing, previous generations have not always recognized it as Grünewald's style. The (non-authentic) signature 'Hohl Bain deli (neavit) M P', which was later affixed immediately beneath the cut-off upright of the cross on the new paper mount, indicates the direction in which its origin was sought in the past. Later—perhaps at the time this sheet was purchased from Basle—the name, 'M. Grünewald' was added.

II

YOUNG MAN CLASPING HIS HANDS (ST. JOHN) (Plate 5)

Chalk; 17⅛ × 12⅝ in.; 43·4 × 32 cm.
Print Room, Berlin-Dahlem (from the Savigny Collection).

While this drawing was undoubtedly also used for the Karlsruhe *Crucifixion* (Fig. 1), Grünewald did not design it with an eye to the painting. The latter must be dated as late as 1526 (cf. my catalogue in: *Matthias Grünewald, The Paintings*, Phaidon, 1958, p. 127), whereas the timidly executed drawing is from a much earlier period. It was used only partially in the late painting, which repeats almost exactly the fleshy hands wrung in distress, parts of the collar area, and the blinking of the upward-looking eyes tortured with suspicion. On the other hand, there are changes in the beard, hair and nose. This corresponds with the late Grünewald's increasing tendency to a heavier, more earthy style, which is in direct contrast to the almost theatrical attitudinizing of the man in the drawing. Since it can hardly be imagined that Grünewald did another drawing from the model for the head of St. John as it appears in the painting, we gain here an insight into the incomparable mastery with which he paraphrased the original model study.

III

DRAPERY STUDY (Plate 3)

Chalk, heightened with white; 5⅛ × 7⅛ in.; 13 × 18 cm.
Smith College Museum of Art, Northampton, Mass.
(formerly Oppenheimer Collection, London; Le Roy M.
Backus, Seattle).

Bottom right a later inscription 'A. Durer'. This drawing
has frequently been connected with the Frankfurt *Trans-
figuration* of 1511 (e.g. Zülch, *Der historische Grünewald*,
Munich, 1938, p. 333, and Arpard Weixlgärtner, *Grünewald*,
Vienna/Munich, Cat. No. 6). Zülch interprets this detail
study as a 'prostrate apostle'. In the popular edition of his
work on Grünewald (Munich, 1949, Fig. 76, text p. 62), he
writes that 'fear has made the apostle hide himself com-
pletely under his cloak'. This explanation is undoubtedly
erroneous but typical of the general belief in a 'surprising'
Grünewald. It does not require much formal experience to
see nothing but the lower part of a seated figure, covered
with a cloak falling in many folds. The two knees can be
clearly distinguished at the top. A similar motif can be seen
in the figure of the Virgin in the *Nativity* of the Isenheim
altarpiece. Stylistically, too, this drawing does not fit in
with the drawings made about 1511, which are centred
around the lost Frankfurt *Transfiguration* (Plates 6–11). The
clearly discernible Late Gothic elements place this drawing
much earlier.

IV

VIRGIN OF THE ANNUNCIATION (Plate 4)

Chalk; 6¼ × 5¾ in.; 16 × 14·6 cm.
Print Room, Berlin-Dahlem.

This drapery study is usually regarded as a preliminary
study for the Isenheim *Annunciation* panel. However, the
relationship is rather general, and is basically confined to the
outline and attitude of the kneeling figure. There are many
differences in the placing of the hands and particularly in the
fall of folds between this *Virgin* and the Isenheim painting.
The technique of drawing the head and curls betrays Late
Gothic influences, which would lead one to believe this
drawing to be a fairly early one, which was later freely
used for the Isenheim altarpiece. The assumed date, c. 1515,
deduced from its supposed relationship to Isenheim would,
therefore, have to be replaced by a much earlier one. If
any of Grünewald's drawings are stylistically related to the
Lindenhardt altarpiece of 1503 (which has not yet been
definitely proved to be by Grünewald) then one might find
it here. No doubt Grünewald worked on other *Annunciation*
pictures, in addition to that of Isenheim. It seems to me that
the second drawing of a *Virgin Annunciate* (Plate 12)—with

a pleated skirt—also relates to a different picture, although
this too is often connected with Isenheim, without any
evident justification.

V

FALLING MAN SEEN FROM THE BACK
(James?) (Plate 6)

Chalk, heightened with white; 5¾ × 8¼ in., 14·6 × 20·8 cm.
Print Room, Dresden (from the G. Winckler Collection,
Leipzig).

In the upper left-hand corner the place-name 'frankfurt',
which was added later, probably still in the sixteenth cen-
tury. The style and technique are similar to the *Falling
Man* in profile, also at Dresden (Plate 7), with clouds in the
foreground. From the attitudes of the figures in these two
drawings it has always been assumed—and rightly so—that
they were connected with the lost *Transfiguration of Christ
on Mount Tabor*, which was commissioned by the Dominican
monastery of Frankfurt and was painted by Grünewald in
1511 (cf. Zülch, *Der historische Grünewald*, Munich 1938,
pp. 121 ff., 332, 361).

From early times, the composition of a *Transfiguration*
had assumed firm iconographic conventions which were
generally followed well into the seventeenth century. The
following are some examples:

1. Evangeliary of Otto III, c. 1000. Staatsbibliothek,
Munich.

2. Byzantine enamel painting of the twelfth century.
The Detroit Institute of Arts.

3. Woodcut from the *Hallisches Heiligthumsbuch of the
Year 1520* (published by R. Muther, Munich 1923, Fig. 81.
'Made from silver and silver ore').

4. Jörg Ratgeb, mural in the Carmelite monastery in
Frankfurt. Illustrated in Zülch, op. cit., p. 221.

5. Peter Flötner, epitaph drawing. University Library,
Erlangen. Illustrated in L. Behling, *Die Handzeichnungen
Grünewalds*, Weimar 1955, Fig. 27.

6. Wolf Huber, pen drawing in the Print Room, Berlin-
Dahlem.

7. Christian Steffan, stucco relief of 1618 in the family
vault of Philip III of Hesse, at Butzbach, Hesse. Illustrated
in *Kunstdenkmäler im Grossherzogtum Hessen, Kreis Friedberg*,
Darmstadt, 1895, Plate III.

This list could, of course, be considerably extended. The
first two examples are representative of the early form of
this type of picture. The third item, which was part of
Cardinal Albrecht's collection of reliquary treasures, and
which must predate the woodcut published in 1520, could
very well have been known to Grünewald, for obvious
reasons. Ratgeb's fresco might possibly reflect Grünewald's

Transfiguration in some way, having been produced at the same place and very shortly after it. Zülch (op. cit., p. 122) sees an echo of Grünewald's composition in the relief by Steffan, which was designed by Philipp Uffenbach, who had studied under a pupil of the old master's. The drawings by Flötner and Huber suggest how little even important contemporaries of Grünewald deviated from the established pattern, and make it possible to believe that Grünewald himself adhered to it closely. This view would be graphically confirmed by the two drawings of falling apostles at Dresden.

In Matthew XVII, 1–6, we read: 'Six days later, Jesus took with Him Peter and the brothers James and John, and brought them up a high mountain to a solitary place. There in their presence His form underwent a change; His face shone like the sun, and His raiment became as white as the light. And suddenly Moses and Elijah appeared to them conversing with Him.

Then Peter said to Jesus,

"Master, we are thankful to you that we are here. If you approve, I will put up three tents here, one for you, one for Moses, and one for Elijah."

He was still speaking when a luminous cloud spread over them; and a voice was heard from within the cloud, which said,

"This is My Son dearly beloved, in whom is My delight. Listen to Him."

On hearing this voice, the disciples fell on their faces and were filled with terror.'

St. Mark depicts the scene in an even more colourful, more 'painterly' manner when in Chapter IX, 3, he describes the garments of the transfigured Christ as becoming 'dazzling with brilliant whiteness—such whiteness as no bleaching on earth could give.' Christ's appearance is further described by Luke IX, 29, in these words: 'And while He was praying the appearance of His face underwent a change, and His clothing became white and radiant.' St. Luke also describes more clearly the state of mind of the apostles immediately before the transfiguration, and before the terrifying cloud entered their field of vision: 'Now Peter and the others were weighed down with sleep; but, keeping themselves awake all through, they saw His glory, and the two men standing with Him.' Thus, in this point, iconographic tradition bases itself more on Luke than on the other versions, since the prostrate apostles see Christ in the company of Moses and Elijah, while awakening from their stupor. They are once again struck with awe by the shadowing cloud; when they come to themselves, they find Jesus alone.

In accordance with the Gospel texts, painters other than Grünewald, therefore, show the three apostles lying down in the foreground, either asleep or stunned, one or two of them showing signs of ecstasy or terror, sometimes shading their eyes to look up towards the transfiguration scene. Above them, in the centre, rises a low hill, on which the full-length figure of Christ stands with arms extended in benediction. To his right and left, often a little higher, floating on clouds appear the gesticulating half-length figures of Moses and Elijah.

The manner in which Grünewald interpreted the Biblical and iconographic tradition in his painting can be deduced from Sandrart's descriptions: 'Particularly praiseworthy is his water-colour representation of the *Transfiguration of Christ on Mount Tabor*, which shows in the forefront a wondrous fair cloud, wherein appear Moses and Elijah, as well as the apostles kneeling on the ground, being composed so excellently in invention, colouring and all refinements that in its uniqueness it is surpassed by nothing else; indeed, it is incomparable in style and character, and a mother of all the graces.' (*Teutsche Academie*, part 1, Nuremberg 1675, II, 3, page 236.) In part 2 (Nuremberg 1679, III, 3, page 68), he speaks more precisely of the apostles as follows: 'Also at the foot of the mountain, the apostles in a very ecstasy of fear.' From these quotations, we can reasonably conclude that Grünewald's *Transfiguration* was not far removed from the established iconographic pattern. In the two Dresden drawings, we can recognize without any doubt the 'apostles kneeling on the ground'. In the drawing showing a figure in profile—generally identified as St. Peter—we even see on the right-hand side the vague sketch of a 'wondrous fair cloud', which was obviously ascending near the place where the three apostles were lying, and from which, higher up, would arise the figures of Moses and Elijah. If, in addition, we take into consideration the word 'frankfurt' on the sheet depicting the back view of a figure, then there is little cause for doubt that we have here two of the six figures which constituted Grünewald's composition of the *Transfiguration*. It remains uncertain how far the figures in the drawings correspond with those in the lost painting. The Isenheim altarpiece shows that he used drawings either without changes (cf. Plates 22, 23), or with slight alterations (cf. Plate 24), or in free adaptation (cf. Plate 27), or with hardly any points in common (cf. Plate 15). Two arguments support the view that the Dresden drawings were used almost unchanged: 1. They cannot have been drawn for 'stock', since the postures are appropriate only to a *Transfiguration*, unless one assumes that they were connected with one of the three lost Mainz altarpieces, i.e. that of the murder of the blind hermit, painted in 1520. The two best-known Italian works on this latter theme are those by Giovanni Bellini (National Gallery, London; a partial repetition in the Courtauld Institute of the University of London) and by Titian (formerly in the Venetian Church

of SS. Giovanni e Paolo). Both paintings show figures clad in cowls, one of whom—St. Peter Martyr—has fallen down and is awaiting or receiving the death-blow, while his companion is trying to escape.

2. A particularly close relationship between the drawing on Plate 7 and the lost painting is suggested by the cloud on the right-hand side of the drawing. This important detail of the vision of the transfiguration was obviously planned for and incorporated right from the beginning.

The latter observation leads us to surmise that Grünewald adhered fairly rigidly to his compositional sketches (e.g. the *Madonna with St. John*, Plate 33, or the *Madonna of Mercy*, Plate 51). When he had made these, he posed models for the single figures and transferred details from the compositional sketch (e.g. the cloud) to the nature or model study without further observation: evidence of his methodical procedure! This, together with the drawing of the *Arms of St. Sebastian* for the Isenheim altarpiece (Plates 22, 23), allows us the most intimate glimpse into Grünewald's 'studio'.

There is, thus, a certain justification for assuming that the two Dresden drawings of men falling down were made for important parts of the Frankfurt *Transfiguration* of 1511. But what about the other four figures which are known to have appeared in the picture? If we suppose they are to be found among Grünewald's surviving drawings, we must look for drawings where the type, posture, gesture and expression suggest a thematic connection with the *Transfiguration* and where style and technique are related to the two Dresden drawings, which were almost certainly done exclusively and immediately in preparation for this painting.

Let us begin with those drawings which contain motifs consistent with a *Transfiguration*.

A remarkable parallel to the Christ figure contained in the sixteenth- and seventeenth-century examples listed on page 80, particularly those by Ratgeb and from the *Hallisches Heiligthumsbuch*, is the man with raised arms, with knees slightly bent, from Hans Plock's Bible at the Märkisches Museum in Berlin. This figure, which has frequently been identified as Moses (Plate 9), is usually connected with the *Transfiguration* (cf. W. Stengel in *Berliner Museen*, N.F., vol. 2, No. 3/4, p. 30; idem in *Zeitschrift für Kunstwissenschaft*, vol. 6, 1952, pp. 65 ff. Also L. Behling, op. cit., p. 98). It is true that the modish costume glimpsed inside the cloak is hardly suitable for a Moses figure, but on the other hand the aged head would support the identification with Moses rather than with Christ (unless one thinks of the third apostle). Nevertheless, such details, which had their origin in the posing model, need not necessarily have been transferred to the painting. This is shown by other cases, such as the drawing of the Virgin at Winterthur (Plate 16),

where only certain parts were incorporated in their original form into the painting, while the head in particular was completely altered.

The figure in Grünewald's drawing shares a most conspicuous peculiarity with the Christ figures of the *Hallisches Heiligthum* and Jörg Ratgeb: the characteristic bending of the knees and the dominance of folds in the voluminous garment—a few, large, parallel tube-like folds which start at the neck and go all the way to the knees and beyond. In the light of these observations, one can hardly doubt that the so-called 'Moses' in Berlin is connected with Grünewald's Frankfurt *Transfiguration*, but that it represents the transfigured Christ Himself, whose head, if nothing else, was greatly changed in the painting.

A proof that this interpretation of the supposed Moses as 'Christ' is not at all fanciful can be found, I believe, in a copy of this Grünewald drawing by an unknown hand—perhaps of a slightly later period—which was found in the same Plock Bible (Plate 50): the quotations on both sides of the figure are words spoken by Christ; the 'modish puffed sleeves' (Zülch) have disappeared, the lower arms are bare, and the patriarchal head of an old man has turned into the head of a younger man with mild, Christ-like features. Special emphasis on these changes is placed by Werner Timm in his article, 'Die Einklebungen der Lutherbibel mit den Grünewaldzeichnungen' in *Staatliche Museen zu Berlin, Forschungen und Berichte*, vol. 1, Berlin, 1957, pp. 110 and 117. Timm points out that Plock identified the original drawing as 'God the Father with the tablets of the law', while the copy shows 'Christ'.

The question whether this newly discovered Berlin sheet can be coupled with the two *Falling Men* in Dresden cannot be answered in the positive without reservations. The grey-black, fine chalk has been applied with an indefinite stroke, and scumbled with an almost painterly effect. It lacks the open, slightly stylized graphic technique of the two Dresden sheets. However, there is a possibility that this drawing was worked over after completion, which would account for the somewhat restless, unco-ordinated impression given by the hatching technique. We must not omit to mention the fact that this drawing is heightened with white—a technique not found in all of Grünewald's works—in a manner closely related to the Dresden sheets. To sum up, from the point of view of motif and composition, this drawing from the Plock Bible could well belong to a *Transfiguration* of Christ. Technically and stylistically, it has certain points in common with the Dresden drawings. If there is, therefore, good reason to believe that this 'Christ' figure is connected with Grünewald's Frankfurt *Transfiguration* of 1511, it is natural to assume the same for the other Grünewald drawings in the Plock Bible, especially as they show a close stylistic and technical relationship. This

includes the *Man with Covered Head* (Plate 10), *St. John* (Plate 8) and, finally, the *Kneeling Man* (Plate 11) in Berlin-Dahlem, about which Timm (loc. cit., p. 112) writes: 'The drawing had been removed previously, presumably in the course of restoration work at the end of the eighteenth century. It was last known to be in the Print Room, Berlin, Catalogue of Drawings No. 4190 (so-called *Mocking Pharisee*).' In this drawing the original calligraphy has obviously been preserved almost in its original form. While it is recognizable in technique and provenance as belonging with the 'Christ' figure (Plate 9) from the Plock Bible, its style and calligraphy leave no doubt whatsover that it belongs to the group of *Transfiguration* drawings at Dresden. To conclude our observations on the four drawings from the Plock Bible: at least two of them are connected with the *Transfiguration* composition, and all four of them can be presumed to have some kind of connection with Grünewald's painting of 1511.

The *Man with Covered Head* (Plate 10) is interpreted by L. Behling as Elijah or an apostle(?); by others as Moses (cf. W. Timm, loc. cit., p. 112). If this figure belongs to the *Transfiguration*, and if it is not simply a bystander, it cannot represent one of the fallen apostles, but must be to Moses or Elijah, i.e. one of the figures which normally appear on either side of Christ, customarily as half-length figures floating on clouds. If the *Man Kneeling* belongs to the same picture, he must be one of the three fallen apostles, presumably James, since the type of figure in Plate 7, shown in profile, must be Peter, while the flowing mane of the young man seen from the back (Plate 6) shows him to be intended for John.

As Zülch remarked, a standing John (Plate 8) would hardly fit into a *Transfiguration*: '(As John), this figure belongs to a different theological theme', he says in *Bildende Kunst*, 1953, No. 5, p. 26. And even if Plate 8 does not represent John, this figure cannot possibly be placed in a *Transfiguration*. Having found the three fallen apostles, Christ and one of the two prophets—who, according to the direction he faces, must have been positioned on Christ's left—the only figure missing is that of the man on His other side, who (to a person looking at the drawing) must have been facing left. The youngish man of Plate 8, however, is looking towards the right, like the figure raising his hands in blessing. He therefore does not belong to this composition. Nevertheless, Grünewald's friend Plock was probably correct in believing him to be intended for John, to judge by the quotations found with it in the Bible.

Summing up, we come to the conclusion that for one of the two figures floating on clouds in the *Transfiguration* we do not possess a figure study, and for the time being the place in the right upper corner of the picture must remain vacant.

We must now try to find an explanation for the undeniable fact that this *John* (Plate 8) cannot be separated from the *Transfiguration* drawings, from the point of view of style, technique and provenance. I offer the following suggestion, with all necessary reservations:

So far, there is still some doubt as to whether Grünewald's painting of the *Transfiguration* was an altarpiece or a mural. As previously mentioned, Sandrart spoke in 1675 of a painting in 'water-colours', and in 1679 he says that 'above the altarpiece', Grünewald had painted the *Transfiguration*. Both have been taken as an indication that it was a mural *in secco* which could be found above Grünewald's altarpiece. However, this conclusion is not necessarily valid. The term 'water-colours' is very vague—perhaps it was simply a painting in tempera or body-colour. In the document referring to Grünewald's work in the Frankfurt Dominican monastery (Zülch, 1938, p. 361), there is express mention of 'eyn tafel' (a board, or panel). Since Sandrart, this reference has been interpreted in a different way, as referring to the four grisailles (St. Lawrence, St. Elizabeth, St. Cyriacus and St. Lucy?) as side panels of Dürer's lost *Ascension* and *Coronation of the Virgin*—the celebrated Heller altarpiece. Sandrart describes the Heller altarpiece (with Grünewald's grisailles) such as he saw it in the seventeenth century, but this gives us no information about the original connection with the surviving Grünewald panels. Perhaps at that time the *Transfiguration* was in fact placed somewhere 'above' the grisailles which flanked the Dürer picture. One must assume, however, that originally Grünewald's grisailles and his *Transfiguration* formed 'eyne tafel' in the Dominican church, i.e. an altarpiece with wing panels. One fact which makes it probable that Grünewald's *Transfiguration* altarpiece also had wing panels is that the Dominican church at Frankfurt had a number of altarpieces dating from the first quarter of the sixteenth century which all corresponded with each other in size, construction and colouring, and consisted of polychrome main panels, but wing panels with single figures in grisaille. The earliest of these altarpieces, which evidently served as a model for the subsequent ones, was painted by the Netherlandish 'Master of Frankfurt'. This is the St. Anne altarpiece of 1505, the wing panels of which have two grisaille paintings each on the outside, one above the other, and in each picture there are two saints.

Then followed Dürer's St. Thomas altarpiece for Jacob Heller of 1508–9. Here, too, the outside wing panels consist of two grisailles, one above the other, and in each picture there are two figures.

In 1511–12, the Grünewald altarpiece followed, with the *Transfiguration* as the polychrome main panel, and grisailles on the wings, one above the other; each of the latter showed

one saint, and four of them have been preserved (Frank-furt-am-Main and Donaueschingen).

In 1520, Hans Baldung Grien created the St. John altar-piece, in a style influenced by Grünewald. By examining its constructional differences from the older altarpieces of the Dominican church, and its similarities with extant parts of the Grünewald altarpiece, perhaps we can gain some in-formation on the actual construction of the original Grüne-wald altarpiece, since it had some points in common with all the other altarpieces of this church, but most of all with that of Hans Baldung, who was inspired by Grünewald. The St. John altarpiece by Baldung shows the *Baptism of Christ* on the central panel; on each of the inner sides of the wings one single large figure (St. Nicholas of Bari and St. Louis of Toulouse), and on the outer sides of these wings, we again find grisailles with two pictures one above the other; in each picture *one* saint—just as in Grünewald. There is no evidence for the existence of fixed wings, but there may have been some. Both Grünewald's and Baldung's altarpieces differ from the two earlier altarpieces in that each grisaille painting only contains one figure. While it is not established whether there were any fixed wings in the two earlier altarpieces, it is fairly certain that the Grüne-wald and Baldung altarpieces did possess such wings origin-ally. This assumption is reinforced by two factors:

1. Grünewald's grisailles in Frankfurt and Donaueschingen, which had been sawn apart, show on the back a column covering the entire length of the wing. It stands to reason that such a simple decoration would be applied only to backs normally not seen, but could not be the sole embel-lishment of an altarpiece when closed. The existence of the two painted columns proves that Grünewald's grisailles constituted the front of fixed wings.

2. So far, no trace has been found of the two movable wings. Nevertheless, it is possible to imagine what they looked like: on the outside, they must have carried single figures, one above the other, of the same size as the figures at Frank-furt and Donaueschingen. When opened, one should per-haps imagine a considerably larger single figure on each side of the *Transfiguration* panel. As in the Baldung altar-piece, these figures would extend to the entire height of the inner side of the wing panels.

We thus believe that we can gain an adequate idea of the composition of the main picture, the *Transfiguration*, from the five drawings preserved in Dresden and Berlin; in addition, we still have the four pictures on the fixed wings (inner and outer panels). What is lacking is an idea of the four smaller single figures on the outer panels of the mov-able wings, and of the two large single figures on their inner panels.

The *St. John* of the Plock Bible (Plate 8), which is considered to be one of the drawings for Grünewald's *Transfiguration*

altarpiece of 1511 on the grounds of style, technique and origin, may be regarded as a study for one of the six missing figures. The bush, vaguely indicated bottom right, cor-responds particularly with the two grisailles at Donau-eschingen.

It may be mentioned that this *St. John*, but facing in the opposite direction, recurs in the much later painting of the *Crucifixion* at Karlsruhe (cf. Fig. 1).

VI

FALLING MAN SEEN FROM THE SIDE
(Peter?) (Plate 7)

Chalk, heightened with white; $5\frac{7}{8} \times 10\frac{5}{8}$ in.; $14 \cdot 8 \times 26 \cdot 7$ cm. Print Room, Dresden (from the G. Winckler Collection, Leipzig).

See notes on Catalogue No. V (especially p. 82).

VII

MAN RUNNING, WITH OUTSTRETCHED ARMS (probably Christ) (Plate 9; cf. Plate 50)

Chalk, heightened with white; $12\frac{3}{4} \times 7\frac{1}{8}$ in.; $32 \cdot 4 \times 18 \cdot 1$ cm. Partly cut out; detached in 1963. The background has been painted in olive water-colour by another hand.
Print Room, East Berlin (from the Plock Bible of the Märkisches Museum, Berlin; also in the collections of A. F. Bühn, Berlin; Philippi, Berlin; and in the Ratsbiblio-thek, Berlin).

Of the three or four Grünewald drawings from the Plock Bible (cf. Plates 8, 10, 11), this is technically the freest and most developed. This drawing was stuck on the inside front cover of the first volume of the Plock Bible. The re-moval of the inscription on the left-hand side, which con-cealed part of the figure in older publications, revealed the right arm of the figure.

The Bible quotations in the inscription suggest that Plock intended to explain this figure as God the Father (cf. W. Timm, 'Die Einklebungen der Lutherbibel mit den Grüne-waldzeichnungen', *Staatliche Museen zu Berlin, Forschungen und Berichte*, vol. 1, Berlin, 1957, p. 110).

As mentioned on page 82, this drawing was copied in free style by a different draughtsman (possibly Hans Plock him-self), and glued inside the front cover of volume II of the Plock Bible (Plate 50). Timm assigned it in 1957 (p. 117, No. 34) to the 'Grünewald workshop'(?) In the copy, the figure measures $14\frac{1}{4}$ in. (36 cm.); what is important is that the copyist interpreted this figure as Christ, to judge from

the text accompanying it. See Catalogue No. V on its presumed connection with the Frankfurt *Transfiguration*, which results in a conjectural date of 1511.

VIII

YOUNG MAN STANDING, HIS RIGHT HAND RAISED IN BLESSING (St John the Evangelist?) (Plate 8)

Chalk, partly scumbled and heightened with white; 9⅝×4⅝ in.; 24·4×11·8 cm.
Print Room, East Berlin (from the Plock Bible of the Märkisches Museum, Berlin. See also Catalogue No. VII for earlier provenance).

This is probably connected with Grünewald's lost Frankfurt *Transfiguration of Christ*, c. 1511 (cf. notes on Catalogue No. V). In 'Die Einklebungen der Lutherbibel mit den Grünewaldzeichnungen', *Staatliche Museen zu Berlin, Forschungen und Berichte*, vol. 1, Berlin, 1957, p. 113, W. Timm points out that the quotations all come from St. John's Gospel, which suggests that Plock himself interpreted the figure as St. John. Of all of Grünewald's representations of St. John, this figure shows the greatest resemblance, in typology and style, to the much later St. John of the Karlsruhe *Crucifixion* (Fig. 1). Both L. Behling (*Die Handzeichnungen Grünewalds*, Weimar, 1955, p. 97) and W. K. Zülch (*Bildende Kunst*, 1953, No. 5, p. 26) doubt the relationship of this drawing with the 1511 *Transfiguration* composition, or even deny it completely.

At this point, we must emphasize that the four drawings from the Plock Bible (Plates 8–11) are not, in fact, identical in technique with the two Dresden drawings, Plates 6 and 7, which have an established connection with the 1511 *Transfiguration*. The former appear in parts to be more sketchy, more painterly and more blurred in execution than the Dresden drawings, whose technique is graphically stricter. Yet there is a strong argument in favour of linking the Dresden drawings with those of the Plock Bible, and thus both groups with the 1511 *Transfiguration*: the so-called *Mocking Pharisee* (Plate 11), as older photographs show, had originally inscriptions similar to the Plock sheets, and therefore belongs to them. Technically, this *Pharisee* stands half-way between the Dresden and the Berlin drawings; one might even say that it is closer to the former than to the latter. Hence one can deduce that the six drawings, Plates 6–11, should be dated about 1511. Apart from the fact that there is no reason why a master should not use different techniques for his drawings in one particular period, closer inspection of the originals gives one the distinct impression that the sheets from the Plock

Bible have been given a painterly 'blurring' effect by a later hand, or perhaps by the owner himself.
The red water-colour used on the shirt, the yellow of the candlestick and the green of the ornamental foliage, have been added later.

IX

BEARDED MAN STANDING, WITH HEAD COVERED (Moses or Aaron) (Plate 10).

Chalk, heightened with white; 11×5⅛ in.; 28×12·9 cm. The figure has been cut out and stuck on.
Print Room, East Berlin (from the Plock Bible of the Märkisches Museum, Berlin; on the verso, the coat of arms of Hans Plock is pasted on).

In the cautious manner with which the white has been applied, this drawing is technically not dissimilar from the two Dresden studies for the *Transfiguration* (Plates 6, 7). The probable connection with this lost work and the resultant approximate date 1511 have been dealt with in the notes on Catalogue Nos. V to VIII. Plock himself did not clearly identify this figure. Although the inscriptions—as far as they have been preserved—all come from the fourth and fifth books of Moses, the first quotation, which is most suitable for the figure shown here, contains Aaron's blessing (cf. W. Timm, 'Die Einklebungen der Lutherbibel mit den Grünewaldzeichnungen', *Staatliche Museen zu Berlin, Forschungen und Berichte*, vol. 1, Berlin, 1957, p. 112, No. 3.II).

X

KNEELING MAN GESTICULATING (so-called Pharisee) (Plate 11)

Chalk, heightened with white; 13¾×8⅜ in.; 34·8×21·4 cm. Print Room, Berlin-Dahlem.

As previously mentioned, this sheet belongs with the set of drawings from the Plock Bible (Cat. VII–IX), not only in technique and style but also in its combination with inscribed tablets, and therefore is also probably related to the Frankfurt *Transfiguration* of 1511. A copy is said to be in the Vatican (W. Timm). Hans Plock evidently regarded the figure as Moses.
This drawing was originally linked with the three drawings Cat. Nos. VII–IX in the Plock Bible and was probably detached towards the end of the eighteenth century (cf. W. Timm, op. cit., vol. 1, Berlin, 1957, p. 112).

XI

ST. DOROTHY (Plate 13)

Chalk, heightened with white; 14⅛ × 10⅛ in; 35·8 × 25·6 cm.
Print Room, Berlin-Dahlem (from the Savigny Collection).

This enchanting drawing, which is similar in expression, style and motif to the Berlin *Virgin of the Annunciation* (Plate 12), is usually linked with the *St. Catherine* (Plate 36), the saint on the verso of the *St. Catherine* (Plate 38), the *Virgin on the Clouds* (Plate 37) and the so-called *Trias Romana* (Plate 39), and related to one of the three lost Grünewald altarpieces of Mainz Cathedral, dated 1520 (*Glorification of Mary*). Moreover, the spherical object in the left bottom corner recalls the astronomical instrument in Plate 30. On the sphere in Cat. No. XI, one can discern a dwarfish figure with an old face and a child's body, whose function and significance have not yet been convincingly explained. In its attitude, the small figure strangely recalls the angel holding a globe shown in the Baroque woodcut after Grünewald reproduced in Zülch's book (1938, Fig. 205).

Nevertheless, I am unable to accept this *St. Dorothy* as contemporaneous with the *St. Catherine*, to which it does not correspond in either technique, style or motif. Their only resemblance is the sketch-like character; however, even this could be the result of later alterations in the case of the *St. Dorothy*. In my view, this drawing is much closer in every respect to the 1511 drawings for the Frankfurt *Transfiguration* (Plates 6–11) than to the *St. Catherine* (Plate 36) or *The Virgin on the Clouds* (Plate 37). The *St. Dorothy* has a special affinity with the figures of saints on the Donaueschingen grisailles of 1511 (Fig. 7), with which it is possibly contemporary.

XII

VIRGIN OF THE ANNUNCIATION (Plate 12)

Chalk, heightened with white; 8⅛ × 8¼ in.; 20·7 × 21 cm.
Print Room, Berlin-Dahlem (from the Savigny Collection).

Since H. Feurstein (*Matthias Grünewald*, Bonn, 1930, p. 14), this has been regarded as a 'second study for the *Virgin of the Annunciation* of the Isenheim altarpiece'. However, whereas the first study (No. IV, Plate 4) can somehow be related to the Isenheim *Annunciation*, this is here impossible. There is no reason to assume that Grünewald should not have prepared and worked on other *Annunciations*. This delicate *Virgin* shows a striking resemblance to the *St. Dorothy* (No. XI) and, therefore, to the two female saints

of the Donaueschingen grisailles, which I am convinced belong to Grünewald's *Transfiguration* altarpiece of 1511 at Frankfurt. If this *Virgin* dates from the same period, it would, of course, be too early for Isenheim.

XIII

HEAD OF AN OLD MAN IN PROFILE (Plate 14)

Chalk, heightened with white; 13⅜ × 10 in.; 34·1 × 25·3 cm.
Schlossmuseum, Weimar (from the Rochlitz Collection)

This drawing is usually described as a portrait of Guido Guersi, preceptor of the Isenheim Antonites, who commissioned Grünewald's main work. This assumption is based on a certain resemblance to the St. Anthony on the *Disputation* wing of the Isenheim altarpiece (Fig. 3), the two figures of which are often believed to represent the painter and his patron. This theory can be found throughout the greater part of the literature on Grünewald, sometimes as a possibility, sometimes as absolute certainty, although it is rejected by H. Köhn ('Die Einsiedlertafel des Isenheimer Altars und das Problem des Stifterbildes', *Wallraf-Richartz-Jahrbuch*, vol. XI, 1939, pp. 215 ff.). In fact, the identification with Guido Guersi does not rest on very solid ground. With its 'baroque' calligraphy, this drawing has no direct stylistic connection with the established studies for the Isenheim altarpiece (for example, see the much more nervous and irregular draughtsmanship in the *Arms of St. Sebastian*, Plates 22, 23). Also, as is well known, the paper has a watermark (a coat of arms crowned with an R and two lilies) which is known to have existed in Mainz from 1506, i.e. almost a decade prior to the Isenheim altarpiece. The drawing could, therefore, be from a much earlier date than the other 'Isenheim' studies. This masterly drawing seems to me to have been influenced by Dürer and to belong to the early part of the second decade. The formal perfection brings to mind the studies for the *Transfiguration* (particularly Plates 6, 7), while the manner of stylization resembles that of the grisailles for the Heller altarpiece, especially those at Donaueschingen.

On the verso, there are figures and notes in Grünewald's own handwriting, together with three studies for coats-of-arms, one of two crossed keys, another of a city gate with three towers and a horizontal key, and the third of an upright sword or sceptre and shield, next to an emblem of a sword standing vertically between two scimitars. (Werner Schade in the Catalogue *Altdeutsche Zeichnungen*, Exhibition of Old German drawings in the Print Room of the Dresden Museum, 1963, p. 46.)

XIV

WOMAN WITH CLASPED HANDS, LOOKING UPWARDS (Mary Magdalen?) (Plates 17, 18)

Chalk; $15\frac{1}{8} \times 11\frac{1}{8}$ in.; $38 \cdot 4 \times 28 \cdot 3$ cm.
Formerly Speck zu Sternburg Collection, Lützschena near Leipzig. (According to Herr H. Nündel, of the Museum der Bildenden Künste of Leipzig, which took over the Speck zu Sternburg Collection after the death of the family's last male heir, the present whereabouts of this drawing are not known.)

Since Guido Schönberger's contribution to *Beiträge zur Geschichte der deutschen Kunst*, vol. I, 1924, p. 164, entitled 'Grünewald's Zeichnungen für den Isenheimer Altar', this drawing has been connected with the Mary Magdalen of the Isenheim altarpiece, while the drawing on the verso (Plate 34), usually regarded as contemporaneous, is believed to be for the Virgin of the Isenheim altarpiece. However, the connection is rather vague. If Grünewald really did these drawings in preparation for the Isenheim altarpiece, he certainly never used them in that work. This is in contrast with the drawing at Winterthur showing a similar motif (Plate 16), the hands of which (Plate 19), do in fact, recur almost without change in the fainting Virgin of the Isenheim *Crucifixion* (Fig. 5).
This drawing (usually referred to as the back of the sheet) of a woman realistically portrayed in modern dress of the time is more likely to represent a lay patroness, such as we find in the Friedburg wing of the Maria-Schnee-Altar (Our Lady of the Snows), than a saint.
On the other hand, the much looser, more sensitive and more expressive half-figure on the back (in most literature referred to as the front) could be related more easily to one of the figures under the Cross. It is catalogued below as No. XXIX.

XV

WOMAN MOURNING (Half length) (Plates 15, 16, 19)

Chalk; $15\frac{7}{8}-16\frac{1}{4} \times 11\frac{5}{8}-11\frac{7}{8}$ in.; $40 \cdot 3 - 41 \cdot 4 \times 29 \cdot 7 - 30 \cdot 2$ cm.
Oskar Reinhart Foundation, Winterthur (from the Savigny and Licht Collections).

This drawing is connected by most writers with the *Crucifixion* of the Isenheim altarpiece (c. 1515), either with the fainting Virgin, or with the kneeling Mary Magdalen. The latter assumption, which is hardly acceptable, has been propounded by H. Feurstein (*Grünewald*, Bonn, 1930, p. 139) and A. Burkhard (*M. Grünewald, Personality and Accomplishment*, Cambridge, 1936, p. 69). It is obvious that the lower arms and hands of the drawing have been used almost without alteration in the Virgin of the Isenheim *Crucifixion*. This might suggest that the drawing was originally made for 'stock' rather than specifically for the Isenheim altarpiece, and therefore it might be dated independently and may have been made earlier than the painting. On the other hand, the *Crucifixion* in particular shows numerous pentimenti: it has been established that the figure of the Virgin was originally upright and that her open eyes were fastened on Christ on the Cross, as is the case in this drawing. The latter has so many similarities with the two studies for apostles at Dresden (Plates 6, 7)—especially in the linear *ductus* and in the thoroughness of detail and nuances—that it could still be placed at the beginning of the second decade. In other words, if it was executed with Isenheim in mind, then it must have been one of the first preparations for that work.

XVI

WOMAN MOURNING (the Virgin?) (Half length) (Plate 20)

Chalk; $15 \times 9\frac{1}{2}$ in.; 38×24 cm.
Ashmolean Museum, Oxford (from the Douce Collection)

This is the only drawing extant with an apparently authentic signature 'Mathis', above the woman's right shoulder. Above it, a later hand has added the word 'Matsia' (?). On the right, an inscription—generally believed to have been added about 1600—says: 'Disses hatt Mathis von Ossenburg des Churfürst v Mentz Moler gemacht Und wo du Mathis geschrieben findest das hat Er mit Eigner handt gemacht' (This has been made by Mathis of Aschaffenburg, painter to the Elector of Mainz. And where you find the signature 'Mathis', it was made with his own hand.) This typical collector's note may have been added by either Grünewald's pupil and heir Hans Grimmer, or the latter's pupil Philipp Uffenbach, who also inherited the Grimmer album (see p. 26). Together with the probably genuine signature it proves the authenticity of the sheet.
In its graphic intensity, this drawing rivals the sheet at Winterthur (Plates 15, 16, 19) which shows similarities in style and motif. It is unusually subtle in its treatment of light reflection. Together with the studies definitely associable with the Isenheim altarpiece and the Stuppach Madonna, it is the sole indisputable basis for establishing Grünewald's drawn *oeuvre*.
The drawing at Oxford has been described as a study for the Isenheim altarpiece by G. Schönberger ('Grünewalds Zeichnungen für den Isenheimer Altar' in *Beiträge zur Geschichte der deutschen Kunst*, vol. I, 1924) and W. K. Zülch (*Der historische Grünewald*, Munich, 1938, p. 333), but this

is purely hypothetical. Others have connected it with the *Disputation* picture at Munich (about 1524–5), particularly Oskar Hagen (*Matthias Grünewald*, Munich, 1919, p. 180), or have found stylistic affinities with the slightly later Karlsruhe *Crucifixion*, about 1526. The latter theory is supported by H. Feurstein (*Matthias Grünewald*, Bonn, 1930, p. 143) and A. Burkhard (*Matthias Grünewald, Personality and Accomplishment*, Cambridge, 1936, p. 70). I can see no justification for either theory, and believe this drawing dates from the beginning of the second decade, i.e. prior to Isenheim.

To what did this study refer? So far it has always been connected with a representation of the Virgin and St. John under the Cross. However, in this type of composition, the Virgin is usually standing on the left of the Cross (as seen by the spectator), in a position inclined towards Christ. Grünewald followed this pattern in the Karlsruhe painting If this drawing (Plate 20) represented the Virgin under the Cross, she would either be standing on its right, contrary to tradition, or else—a rather forced solution—she would be turning away from her Son. Instead, one might consider a completely different scene of the Passion: the Lamentation over Christ. It should be recalled how much this *Woman Mourning* resembles one of the Maries in Nicolò dell' Arca's famous terracotta group in S. Maria della Vita in Bologna. There is also an unmistakable affinity with the mourning Magdalen in the large Grünewald copy in the museum at Donaueschingen (supposedly c. 1515–16).

XVII

HEAD OF A WOMAN (Plate 21)

Chalk; 7⅞ × 5¾ in.; 20·1 × 14·7 cm.
Louvre, Paris, Cabinet des Dessins (Collector's marks of Nicolas Coypel and Robert de Cotte).

This drawing is sometimes associated with the Isenheim altarpiece, although there is no concrete evidence for this. O. Hagen (*Matthias Grünewald*, Munich, 1919, p. 192) made the interesting comparison with Leonardo's *Virgin and Child with St. Anne* in the Louvre—an idea which recurs the following year in L. Réau's book *Matthias Grünewald et le retable de Colmar*, Strasbourg, 1920, p. 297.

However, the strictly frontal position, the bust-like aspect of the composition, the realistic headscarf and the inescapable impression of a close model-bound objectivity seem to me to point much rather to a portrait drawing. Among all Grünewald's other drawings, only the *Head of a Young Woman* (Plate 26) in Berlin might possibly be such a portrait. Ernst Buchner (in *Wallraf-Richartz-Jahrbuch*, 1930, pp. 170 ff.) ascribed to Grünewald a number of painted

portraits in the Alte Pinakothek (store) at Munich, in a private collection at Basle, and the two excellent Rieneck portraits in the Wallraf-Richartz Museum at Cologne, but I consider this claim hardly justified in the face of the spiritual and formal intensity of this portrait-like head (Plate 21).

In spite of the realistic vigour of form and expression, we find here parallels to the imprecise modelling and the nervous calligraphy of the Isenheim drawings (cf. in particular Plates 22, 23), so that, in fact, the most likely date of this drawing might be about 1515.

XVIII

STUDY FOR THE BUST OF ST. SEBASTIAN
(Plate 22)
Lower arms.

Chalk; 9⅜ × 7½ in.; 23·8 × 18·9 cm.
Print Room, Dresden (from the G. Winckler Collection, Leipzig).

XIX

STUDY FOR THE BUST OF ST. SEBASTIAN
(Plate 23)
Upper arm with part of torso.

Chalk; 11⅜ × 8 in.; 28·9 × 20·3 cm.
Print Room, East Berlin (before 1938, in the G. Winckler Collection, Leipzig; Campe, Leipzig; Hasse, Hanover; Ehlers, Göttingen).

On the verso of each of these two studies, there are studies of a seated St. Anthony (Catalogue Nos. XX, XXI, Plates 24, 25).

The two parts of the *St. Sebastian* study were unquestionably used for the figure of St. Sebastian in the Isenheim altarpiece. The only differences are found in the chest section and in the muscle of the upper arm, the left contours of which are more detailed in the painting. This drawing was done in immediate preparation for the painting, and can, therefore, be dated with a fair amount of certainty between 1512 and 1515. The date 1515 is inscribed on the ointment jar of the Magdalen in the *Crucifixion* panel, of which the *St. Sebastian* (Fig. 6) forms the right wing.

It is also important to remember that Grünewald himself must have cut the sheet, and this at the time when he was working on the Isenheim altarpiece. The figures of the two hermits, which do not correspond to each other in style, were drawn on the backs of the sheets and are quite separate. There is no overlapping which, unless there is a fairly wide strip missing between the two parts, would definitely have

been noticeable at least at one point: the bottom corner of the Berlin *St. Anthony*'s cloak is cut off by the right-hand edge without, however, reappearing on the corresponding bottom left-hand corner of the Dresden *St. Anthony*. Both figures are related to the painted figure of *St. Anthony* in the *Hermits* panel of the Isenheim altarpiece. Of the two drawings, the more delicate one, in Dresden, is more akin to the *Arms of St. Sebastian* in its calligraphy whereas the firmly worked Berlin *St. Anthony* seems quite different and appears to date from a later period. Grünewald probably cut up the Sebastian study after he had completed this wing. It was only then that he began to make preparatory drawings for the *Hermits* wing. This sequence of events is confirmed by the Isenheim pictures. The relatively classical figures of saints on the wings on either side of the *Crucifixion* panel (Figs. 4, 6) obviously represent an early stage of the work. Their statuesque style is reminiscent of Dürer, and their relatively firm substantiality of Grünewald's drawings for the *Transfiguration* of 1511. In comparison, the *Hermits* picture is infinitely more daring in colouring and formal composition, representing the final stage of his work on the Isenheim altarpiece, during which he may also have gone over the *Crucifixion* panel once more, which would account for the many alterations, which have been observed.

XX

STUDY FOR *ST. ANTHONY* (of the *Disputation* picture of the Isenheim altarpiece) (Plate 24)

Chalk, heightened with white; 9⅜ × 7½ in.; 23·8 × 18·9 cm. Print Room, Dresden (from the G. Winckler Collection, Leipzig).

Verso of No. XVIII (Plate 22)—Lower arms of the cut-up drawing of St. Sebastian.

As explained above, Grünewald himself must have cut up the Sebastian study (Plates 22, 23) while still engaged on the Isenheim altarpiece (c. 1512–15), and made the drawing of St. Anthony only after completion of the St. Sebastian wing. The same applies to the other drawing of St. Anthony, in a distinctly different style, on the Berlin section of the cut-up St. Sebastian drawing (Plate 25).

These two drawings which, though different in style, are very similar in motif and are both related to the *Hermit* wing of the Isenheim altarpiece (Fig. 3), pose a riddle which is hard to solve. Neither figure has been used in the painting without alteration. In posture and fall of the drapery, the painting follows the Dresden drawing more closely than the one in Berlin. However, important details, including certain folds, which appear in the painting, can be found in

the Berlin drawing. As the latter shows stylistic affinity with the *St. Catherine* (Plate 36; cf. notes on p. 94), which can be dated about 1520, it could be a later work, possibly copied from the *painted* figure (see p. 25).

The Dresden drawing is executed with cautious, tentative strokes. Grünewald started the work with delicate preliminary outlines, then he covered these with stronger chalk lines, which he finally scumbled like a painting. The total effect of tone is nervous, patchy and curiously incoherent. These characteristics indicate that this was indeed the real preparatory drawing for the painted figure of St. Anthony, for it comes closest in style, calligraphy and technique to the *Arms of St. Sebastian* (Plates 22, 23), the most indisputable of all the Isenheim drawings. Having served its purpose, the latter drawing was cut up, and it can be presumed that the drawing of St. Anthony at Dresden was done immediately afterwards.

XXI

ST. ANTHONY (Plate 25)

Chalk, heightened with white; 11⅜ × 8 in.; 28·9 × 20·3 cm. Print Room, East Berlin.

Verso of No. XIX, Plate 23. (Study of upper arms of St. Sebastian for the Isenheim altarpiece.)

This study of a seated hermit (with the old inscription 'Isnaw' in the top right-hand corner, which is usually understood to mean Isenheim) must be considered in conjunction with the Dresden drawing (No. XX), and the figure of St. Anthony in the *Disputation* panel of the Isenheim altarpiece (Fig. 3). Both drawings of St. Anthony appear on the backs of the cut-up sections of the *Torso of St. Sebastian* (Plates 22, 23), which Grünewald used for the St. Sebastian wing of the Isenheim altarpiece and which was probably in direct preparation for the latter. As explained in the notes on Catalogue No. XX, the Dresden *St. Anthony* was probably a study for the Isenheim figure and was executed immediately prior to the painting, whereas the Berlin *St. Anthony* was possibly drawn after completion of the painting. This supposition is supported by the close technical and stylistic relationship with the *St. Catherine* (Plate 36), to be dated c. 1520, and the peculiar fixity of the whole work, which shows no trace of exploration, discovery and development such as one would expect in a preliminary study. On the contrary, it was evidently based on an existing form, probably painted: this can only be the painted figure of *St. Anthony* in the *Disputation* panel of the Isenheim altarpiece (c. 1515). However, the drawing does not copy the painting point for point but modifies it, perhaps with a view to some intended use in connection with a different picture.

XXII

SO-CALLED SELF-PORTRAIT OF GRÜNEWALD (Plate 27)

Chalk, heightened with white, later partly drawn over with pen and Indian ink; 8⅛×6 in.; 20·6×15·2 cm.
University Library, Erlangen.

This sheet has been considerably defaced; in the left top corner it shows the wrong date 1529 (i.e. a year after Grünewald's death); under it, the monogram G within M, which was either copied from the genuine monogram on the *Trias Romana* in Berlin (Plate 39), or was possibly re-drawn over an original signature which had become smudged. It is noteworthy that Sandrart used this drawing as a model for his engraved portrait of the aged Grünewald in the 1679 edition of the *Teutsche Academie*, which shows neither the monogram nor the date, no doubt because they were not on the original. Another later addition is a list of the names of 25 artists on the reverse, the fifth being 'mathes von Aschaffenburg'. Sandrart, who saw this drawing in the possession of Councillor Philip Jacob Stromer in Nuremberg, was apparently not the first to consider it a self-portrait by Grünewald. There is a copy of this Erlangen drawing at Kassel (reproduced by W. K. Zülch in *Der historische Grünewald*, Munich, 1928, illust. 182, text p. 334), to be dated about the beginning of the seventeenth century. In addition to the monogram G within M above the head, this bears the inscription 'Contrafactur des hochberümpten Malers Mathes von Aschaffenburg' ('Portrait of the illustrious painter Mathes of Aschaffenburg'). On the back, an even later note was added: 'Matheus Grünewald von Aschaffenburg, sehr wares Porträt von ihm selbst gezeichnet, hat floriert um das Jahr Christi 1500' ('Matheus Grünewald of Aschaffenburg, very true portrait drawn by himself, flourished around the year of our Lord 1500').

In its present condition, the drawing might perhaps be acceptable as a portrait of a painter; however, it is difficult to say with absolute certainty to what extent it conforms to the original and how far the person who carried out the alterations understood the painter's intentions. At any rate, the characteristics of the head are not necessarily those of a self-portrait of the beginning of the sixteenth century, particularly the upward direction of the gaze. One is reminded more of a visionary writer than of a Renaissance painter—e.g. St. John on Patmos. I am thinking of Hans Burgkmair's portrait in the St. John altarpiece of 1518 at Munich.

An artist drawing a portrait of himself would normally look into the mirror and thus at the spectator (unless he used a double mirror), but the man in this drawing has his gaze fixed on the other world, and therefore we can exclude the idea that this was Grünewald or that he looked like this man.

Doubts about the authenticity of the lower portion of the drawing with the supposed painter's hand are reinforced by the fact—which has often been observed—that almost the identical head appears as the head of St. Paul in the 'Disputation' panel of the Isenheim altarpiece. The similarity is so striking that it seems certain that the drawing was used for this painting, but the right arm and hand are in an entirely different position, in a gesture which could never have been developed from a painter's pose (see Fig. 3). A similar head recurs in the *Miracle of the Snow* at Freiburg (the old man kneeling, far left). One cannot attempt to assign an approximate date to the drawing at Erlangen, in view of its deteriorated condition.

XXIII

HEAD OF A YOUNG WOMAN (Plate 26)

Chalk; 10⅞×7¾ in.; 27·7×19·6 cm.
Print Room, Berlin-Dahlem.

This particularly delicate drawing is on the reverse of one of the heads of the *Screaming Figure* (Plate 40), which are (probably correctly) connected with one of the three lost Grünewald altarpieces of 1520 for Mainz Cathedral. Hence, this Woman's Head has been regarded as a study for the *Murder of the Blind Hermit* (see p. 95), but this is very much in doubt and is not supported by any concrete arguments. This head is much more in the nature of a portrait and should, moreover, date from an earlier period. The sensitive individuality of the delicate, quite un-Dürer-like line suggests that the drawing was executed around the time of the Isenheim altarpiece.

XXIV

STUDY FOR THE *MADONNA OF STUPPACH* (Plate 28)

Chalk and water-colour; 12¼×11 in.; 31·4×27·8 cm.
Print Room, Berlin-Dahlem (from the Savigny Collection).

Like the drawings on Plates 18, 22 and 23, this study was demonstrably translated into a painting almost without alteration. We find almost the same composition, with almost identical details of drapery, in the *Madonna of Stuppach* (Fig. 8). The only notable differences in the painting are: the missing crown, the fall of the hair, the upper part of the gown, and the position of the Child's arms and legs. The tree shows more movement in the painting than it does in

the drawing. All this can be explained as natural alterations conditioned by technique, format and composition. Otherwise, there are so many resemblances that it is perfectly justifiable to regard the drawing as a preliminary study for the painting. If the *Madonna of Stuppach* is in fact—as is usually presumed—the main panel of the *Maria-Schnee* altarpiece which Grünewald completed in 1519 for the chapel of that name in the Stiftskirche at Aschaffenburg (cf. my Catalogue in *Grünewald, The Paintings*, Phaidon, pp. 121 ff.), then we have an approximate date of about 1519 for this drawing. This would provide one of the very few 'fixed points' from which one might follow Grünewald's 'development' as a draughtsman, though with many reservations. Of particular stylistic importance are the trees, loosely jotted down on the right. Their summary evocative style might be termed impressionist in the sense of an absolute immediacy between perception and recording. Similar details are to be found in the drawings on Plates 29 and 32, which may therefore be connected with the study for the *Madonna of Stuppach*.

XXV

KNEELING MAN, HIS TRAIN HELD BY TWO WINGED FIGURES (Plates 29, 30)

Chalk, heightened with white; $11\frac{1}{4} \times 14\frac{3}{8}$ in.; $28 \cdot 6 \times 36 \cdot 6$ cm. Print Room, Berlin-Dahlem (from the Radowitz Collection).

The subject-matter of this picture is widely disputed. The scene is apparrently taking place in a forest. The kneeling man with the voluminous cloak seems to be wearing a crown, perched at a jaunty angle on his forehead, like the Moorish king in the *Adoration of the Magi* executed by one of Grünewald's pupils on the back of Grünewald's panel in Freiburg. In his left hand, the man holds the handle of a staff-like object, perhaps a sceptre. His right hand is extended in a gesture of either blessing or pointing. He is kneeling in front of a platform, on which lies a transparent spherical object, probably an astrolabe. The two winged figures carrying the massive train, in spite of their 'demonic' character, may be cherub-like angels whose wings sprout from the peculiarly lumpy arms instead of from the back.

The astrolabe, and a certain similarity with the *Adoration of the Magi* at Freiburg mentioned above, might allow us to regard this drawing as a preliminary study for an *Adoration of the Magi*—albeit a highly fantastic one—as is often assumed in earlier Grünewald literature. At least, the forest setting would not invalidate such a supposition. On the other hand, it seems hardly likely that one of the kings should have angels as his train-bearers.

There is more to be said for the interpretation of this figure as Christ in a *Coronation of the Virgin*. In this scene, Christ has often been depicted in a similar manner by artists of Grünewald's time, especially in Germany. One example is the shrine of the St. Wolfgang altarpiece by Michael Pacher. As far as I know, however, it is most unusual for this particular scene to be shown taking place in a forest; the most usual setting seems to be 'heaven'. Apart from this unusual feature, however, one might agree with the almost unanimous conclusion of modern scholars, who regard this drawing as a preliminary study for a *Coronation* or *Glorification of the Virgin*, possibly for the one that Grünewald seems to have executed in 1514 as a commission for Canon Heinrich Reitzmann in the village church at Oberissigheim near Hanau (cf. W. K. Zülch, *Der historische Grünewald*, Munich, 1938, pp. 335 ff. and pp. 338 ff.). The form and content of the planned altarpiece were described in Reitzmann's second Will, written in Latin, in the following words: 'nova tabula cum quatuor ymaginibus in summo altare, videlicet gloriosissime Marie virginis in medio, Sanctorum Vincentii patroni in dextro Hieronimi in sinistro et sancti Georgii patroni in pede tabule equitandi etc. . . .' The quotation shows how loose the connection is between the drawing and the strange commission for Oberissigheim—a connection which is almost universally accepted nowadays without question. But whether the drawing does, indeed, refer to the Oberissigheim altarpiece or to some other lost work of Grünewald's, it is fairly certain that the interpretation as Christ in a *Coronation of the Virgin* is correct.

If we are to come to any positive conclusions about the subject and possibly about the date of this drawing, we must look for other Grünewald drawings which in some way harmonize with it, either in style or motif.

To begin with the motif: the conspicuous astrolabe can be found again in the *St. Dorothy* (Plate 13), where it is also lying on a platform. This presents a difficulty which I regard as characteristic of all of Grünewald's drawn *oeuvre*. The main figure in the *St. Dorothy* obviously shows a different style from the *Kneeling Man*, both in the detailed drapery folds and the exceedingly fine calligraphy. As mentioned on pages 24 and 81, the *Dorothy* must have originated in the period of the Frankfurt/Donaueschingen grisailles (1511), i.e. much earlier than the *Kneeling Man*, if this drawing really has any connection with the *Madonna of Stuppach*, and if the latter can be dated 1519 (date of the *Maria-Schnee* altarpiece). The problem might perhaps be solved by assuming that Grünewald actually did draw the *St. Dorothy* about 1511 for Frankfurt, and later wished to use it again for a completely different composition. This would have compelled him to revise the old drawing. At that time, he might have added the platform, astrolabe and

child, as well as the whole sketchwork of light and shade all around the saint in order to establish the connection with the new work.

Another characteristic motif in this drawing is the bare trees with thin trunks and branches; they recur in similar form in the *Pilgrim Praying* (Plate 32) in the Albertina, Vienna, and in the study for the *Madonna of Stuppach*, Plate 28. The same drawings (Plates 28 and 32)—and these two only —form a stylistic parallel with the *Kneeling Man*; not even the study for *St. Peter* on the verso of the drawing in the Albertina (Plate 31) seems to belong to the same style. The most pronounced, almost harsh, features in the *Kneeling Man* are the rough, sketchy, broad strokes, particularly those suggesting the platform, the astrolabe and the small tree with leaves in the centre. The closest approach to these elements can be found in the drawing in the Albertina (Plate 32) although it is in a quieter tone. In particular, it is worth comparing the sketchy execution of the foliage in the background of the latter drawing, which is unusual in Grünewald's work.

Another conspicuous peculiarity of style in the *Kneeling Man* is a marking of the wooded background behind the angels with quite un-plastic, obstinate outlines of an un-surpassed calligraphic ruthlessness. Similar treatment was accorded to the trees in the study for the *Madonna of Stuppach*. Grünewald revised the *St. Dorothy* (Plate 13), which dates originally from an earlier period, in the same sense, although we cannot include the latter drawing in this context since it belongs more closely to the Maria-Schnee chapel and the *Coronation of the Virgin*, and may have been re-used for one of the Mainz altarpieces, c. 1520, as explained on p. 94. What is undeniable, however, is that the drawing for the *Madonna of Stuppach* (Plate 28), the *Hermit* in the Albertina (Plate 32) and the *Kneeling Man* (Plates 29, 30) must be regarded as a coherent group in style and motif, and may be connected with one and the same painting. From the foregoing observations, we may conclude, with all necessary reservations, that the altarpiece which included the *Madonna of Stuppach*, also had a *Coronation of the Virgin*, to which the Christ of this preliminary drawing refers. We have already suggested that even a *St. Dorothy* fits into an iconographic relationship. All three motifs—the Virgin (or Nativity), Coronation of the Virgin, and St. Dorothy—have their place in the pictorial programme of *Our Lady of the Snows* (Maria-Schnee). They are all present, together with other motifs, in the *Basilica of S. Maria Maggiore* by Hans Holbein the Elder, in the Augsburg Picture Gallery.

Nowadays the *Madonna of Stuppach* is, almost without exception, identified with the *Maria-Schnee* altarpiece of Aschaffenburg, which was completed in 1519. If this is correct, then it also included a *Coronation of the Virgin* and a

St. Dorothy, so that we would have to imagine this altarpiece quite differently than was thought in the past. Provisionally, it would seem justifiable to assume a date of about 1519 both for the *Kneeling Man* and for the *Apostle* in the Albertina, as well as for the revision of the *St. Dorothy* (Plate 13).

XXVI

STANDING SAINT PRAYING WITH SWORD AND PILGRIM'S STAFF (Plate 32)

Chalk, heightened with white; $14\frac{1}{2} \times 11\frac{5}{8}$ in.; $36\cdot8 \times 29\cdot6$ cm. Albertina, Vienna.

This figure is interpreted as St. Joseph by O. Hagen (*Mathias Grünewald*, Munich, 1919, p. 186), H. Feurstein (*Mathias Grünewald*, Bonn, 1930, p. 141) and L. Behling (*Die Handzeichnungen . . . Grünewalds*, Weimar, 1955, p. 105), whereas others regard him as St. Paul. For further comments on the group of drawings to which this sheet belongs, see notes on Catalogue No. XXV, which discuss its possible connection with the Oberissigheim altarpiece (from 1514) or more probably with that of Aschaffenburg (up to 1519). If the latter connection is accepted, this drawing should be dated about 1519.

XXVII

ST PETER (Plate 31)

Verso of preceding drawing (with similar technique)

We have nothing to prove whether or not this sketch of *St. Peter* has anything to do with the same altarpiece (Oberissigheim or Aschaffenburg) as the saint on the recto of the sheet. There is, however, a noteworthy similarity of this *St. Peter* with the *St. Anthony*, one of the two single figures in the Isenheim altarpiece (Fig. 4). The question is whether Grünewald used this more or less hasty sketch as a study for Isenheim, which is nearly contemporary with Oberissigheim, or whether it is a repetition of the Isenheim figure, perhaps sketched for the purpose of using it again at either Oberissigheim or Aschaffenburg, and in any case to be dated between 1514 and 1519.

XXVIII

MADONNA AND CHILD WITH ST. JOHN (Plate 33)

Chalk; $11\frac{1}{4} \times 14\frac{3}{8}$ in.; $28\cdot6 \times 36\cdot6$ cm. Print Room, Berlin-Dahlem. Verso of No. XXV (Plate 30).

This is one of the freest, most sketchy drawings by Grüne-wald. The looseness of the calligraphy, which evokes strange echoes of the late Michelangelo, is particularly surprising in view of the size of the sheet. The carefree, fleeting manner in which this improvisation was jotted down has no parallel in any other of Grünewald's drawings, which cannot therefore be used as help with the dating of this drawing. There are two other sketches which show almost the same lack of precision and the same rapidity of execution: the verso of the sheet at Vienna (Plate 31) and the verso of the Berlin *St. Catherine* (Plate 38). However, both these drawings show such differences in graphic design and expression that they cannot be brought into direct connection with this *Madonna and Child*. Neither are there any technical parallels in Grünewald's drawings which one could use as indications for a probable date of this Madonna. (As Winkler has explained, apart from the *Screaming Figure* in Berlin [Plate 40] and the *Head of a Beardless Old Man* [Plate 42], this Madonna is the only pure chalk drawing in Grünewald's extant *oeuvre*, i.e. without heightening with white or other brushwork [cf. F. Winkler, 'Die Mischtechnik der Zeichnungen Grüne-walds', published in *Berliner Museen*, N.F., vol. 11, No. 3/4, 1952, p. 39].)

This sketch has often been connected with the *Madonna of Stuppach*, which was probably completed in 1519. The childlike figure looking over the Virgin's shoulder might be the young St. John, and the Christ Child is obviously touching a lamb's head. If one disregards the presence of St. John and the lamb, and the different position of the Christ Child, one can only agree with the supposed connection with the *Madonna of Stuppach*. There are similarities not only in mood and atmosphere, but also in the type, position and hairstyle of the Madonna. Moreover, this sketch is one of Grünewald's works which show unmistakable features of mannerism. Since Grünewald's most mannerist picture is the *Miracle of the Snows* at Freiburg, which can be dated with certainty from 1519, one may assume that this date is equally applicable to this sketch.

XXIX

A YOUNG WOMAN LOOKING UPWARDS (The Magdalen?) (Plate 34)

Chalk; 15½ × 11⅛ in.; 38·4 × 28·3 cm.
(Formerly Speck von Sternburg Collection, Lützschena near Leipzig.)

Verso of drawing No. XIV, but indubitably of a much later date. There is no reason why the artist should not have used the blank space on the back of old drawings for later projects. The technique and careless lines recall the *Madonna* of Plate 33. Unmistakable mannerist features suggest that this drawing was done near the time of the small *Crucifixion* at Washington and the *Maria-Schnee* altarpiece, completed in 1519.

XXX

NUDE FLUTE-PLAYER (Plate 35)

Chalk; 10⅝ × 7⅝ in.; 27·1 × 19·5 cm.
Formerly F. Koenigs Collection, Haarlem (from the Savigny Collection).

All earlier writers have attributed this drawing to Grüne-wald. W. Niemeyer was the first to question this ('Hans Grimmer, Ein deutscher Manierist als Gewinn der Marburger Zeichnungsfunde', in *Zeitschrift für Kunstgeschichte*, vol. 16, No. 1, 1953, pp. 61 ff.), and to think of Grünewald's pupil Hans Grimmer. Although the stylistic connection with Grimmer is not yet proven—and even less so for the Marburg drawings, see Appendix a–f below—it cannot be denied that there is some risk in subscribing to the generally accepted attribution of this work to Grünewald. However, I think this is a risk that can reasonably be taken. In its general conception, this drawing is quite different from the rest of Grünewald's *oeuvre*; it is more reminiscent of Dürer's work, whose *Flautist* in the Jabach altarpiece (1503; wing in the Wallraf-Richartz Museum in Cologne) seems to anticipate the Grünewald drawing, though clothed and facing the other way. (This has previously been remarked by Zülch in *Der historische Grünewald*, Munich, 1938, p. 334.) In its very bold, almost elegant calligraphy this sheet is not typical of Grünewald's generally accepted style.

What does remind us of Grünewald are details such as the expressive, mannerist position of the fingers (to be compared with Plates 28, 33, etc.) and the peculiarly formed feet, which are similar in type to those of the *Hermit* in the Albertina (Plate 32). A nervous treatment of lines, particularly noticeable in hands, arms, calves and feet, seems to be close to the style of the *Madonna* in Berlin (Plate 33). This nude study of extraordinary quality is worthy of a Grünewald. If he was indeed its author, this drawing must have been done, to judge by its mannerist character, around 1519, when he completed his most mannerist painting, *Our Lady of the Snows* (Museum, Freiburg).

The identity of this figure can only be conjectured. The most likely suggestion would be that of a shepherd or Moor playing the flute. At any rate, a figure such as this belongs to the tradition of the various stages of the Adoration of the new-born Christ, and the earliest recognition of the Child of Bethlehem as Son of God and King of the Jews. This

again leads us to the *Maria-Schnee* altarpiece, the Freiburg wing of which shows, on the reverse, the group of the Three Kings by one of Grünewald's pupils. The problems connected with this altarpiece, which is one of the most important works of Grünewald, cannot be solved here. (The author has been working on this subject for some considerable time and hopes to publish a special investigation.)

XXXI

THE VIRGIN STANDING ON THE MOON (Plate 37)

Chalk and water-colour; $12\frac{3}{4} \times 10\frac{1}{2}$ in.; $32 \cdot 5 \times 26 \cdot 8$ cm.
Boymans-van Beuningen Museum, Rotterdam (from the Savigny and Koenigs Collections).

The upper right-hand corner bears the inscription 'menz', which was added in the sixteenth century. This points to a connection of this drawing with one of Grünewald's three altarpieces for Mainz Cathedral, which were destroyed in the Thirty Years War. The drawing itself also suggests a connection with one of those altarpieces which J. von Sandrart describes as follows: 'Furthermore, there were, from this noble hand, three altarpieces in the Cathedral of Maynz on the left-hand side of the choir, in three different chapels; each was painted with two wings inside and out. The first was Our Lady with the little Christ Child in the cloud; down below on earth, many saints attend with particular gracefulness, such as St. Catherine, St. Barbara, Cecilia, Elizabeth, Apollonia and Ursula, all drawn so nobly, naturally, gracefully and correctly and also coloured so well that they seem to be more in heaven than on earth.' (*Teutsche Academie*, Nuremberg, 1675, first part, II, 3, p. 236.)
Much iconographic research on this drawing has shown that this must be an apocalyptic Virgin on the Moon. (A good survey of this research was made by L. Behling in *Die Handzeichnungen . . . Grünewalds*, Weimar, 1955, pp. 107 ff.) Particularly conspicuous are the crown which was evidently developed from earlier models, with its two high points, and a sort of Aesculapius' staff—no doubt an attribute of salvation in the literal sense. Of the saints named by Sandrart, at least one can be definitely identified in a drawing, the *St. Catherine*, Plate 36. However, it is impossible to say with certainty which of those named is represented by the female saint on the verso of the *Catherine* sheet (Plate 38). The *St. Dorothy* (Plate 13) which has also frequently been associated with this altarpiece (as mentioned on pages 24, 86, 91), probably dates from an earlier period.

As explained on page 95, one of the three Mainz altarpieces bore the date 1520. It would be possible to apply this date to all three Mainz altarpieces. If this is justified, the *Virgin standing on the Moon* would also date from about 1520, together with Plates 36 and 38–41.

XXXII

ST. CATHERINE (Plate 36)

Chalk, heightened with white and partly with water-colour; $12\frac{1}{2} \times 8\frac{1}{2}$ in.; $31 \cdot 6 \times 21 \cdot 5$ cm.
Print Room, Berlin-Dahlem (from the Savigny Collection).

As mentioned several times before, this drawing must be associated with Plates 37–41, and is related to one of the lost Grünewald altarpieces of Mainz Cathedral, which were all painted about 1520. In Sandrart's description of the altarpiece with the *Virgin standing on the Moon* (see notes on Catalogue XXXI), there is express mention of St. Catherine, whose head here reaches the clouds while her feet seem to be poised on rocky terrain: 'down below on earth, many saints attend with particular gracefulness, such as St. Catherine . . . etc.' As she is mentioned first, she probably stood on the far left.

XXXIII

FEMALE SAINT (Plate 38)

Verso of No. XXXII (Plate 36).
Technique similar to No. XXXII.

Like the drawing in the Albertina (Plate 32), this study on the verso is a fleeting and delicate summary sketch, with hardly any detail. It is not certain whether this hasty sketch, together with the precise drawing on the other side, belongs to the drawing on Plate 37 and thus also refers to the altarpiece of Mainz Cathedral dating from 1520, which had as its centre panel a Madonna in the Clouds with six female saints standing below. The flower which this figure is holding in her hand suggests that she is either St. Dorothy or St. Elizabeth. Possibly she represents the latter, who was described by Sandrart (cf. note to Cat. No. XXXI) as standing fourth from the left, or third from the right, beneath the Madonna.

XXXIV

TRIAS ROMANA (Plate 39)

Chalk; $10\frac{3}{4} \times 7\frac{7}{8}$ in.; $27 \cdot 2 \times 19 \cdot 9$ cm.
Print Room, Berlin-Dahlem.

Bottom centre, the initials G within M. This is the only authentic monogram on a drawing by Grünewald (unless the similar monogram on the so-called Self-Portrait at Erlangen—Cat. No. XXII—is based on an authentic signature). There is a certain similarity with the monogram on a baroque woodcut after Grünewald (Zülch, *Der historische Grünewald*, Munich, 1938, illust. 205). Only slight differences exist between this and the monogram, completed by an 'N', on the frame in the Stiftskirche at Aschaffenburg (which, in turn, resembles the not definitely authentic signature on the *St. Lawrence* grisaille at Frankfurt).

This study could possibly be connected with a part (lunette) of one of the three lost altarpieces for Mainz Cathedral, datable about 1520, particularly as it corresponds in style with the Mainz drawings, Plates 36 and 37.

The abundant literature on the iconography of this puzzling drawing is listed and evaluated by L. Behling in her book, *Die Handzeichnungen . . . Grünewalds*, Weimar, 1955, p. 114. The following sentence sums up the result of her findings: 'In Ulrich von Hutten's pamphlet "Vadiscus sive trias Romana" of 1520, published in German in 1521 under the title "Vadiscus oder die Römische dreyfaltigkeit", he castigates the three vices of Rome: "Pride, lechery, avarice".'

XXXV

SCREAMING HEAD (Plate 40)

Chalk; $19\frac{7}{8} \times 7\frac{3}{4}$ in.; 27·6 × 19·6 cm.
Print Room, Berlin-Dahlem.

Bottom right, a Grünewald monogram, probably not authentic. On the verso, the head of a young woman (Plate 26) which I have interpreted as a portrait and which certainly has no meaningful connection with this realistic head of a youth screaming, or possibly singing. Similar in motif and style (though not heightened with white as is the other drawing) is another head of a screaming figure, which is also in Berlin (Plate 41). Both drawings have always been bracketed together—notwithstanding the difference in technique—and connected with one of the three Grünewald altarpieces of Mainz Cathedral, lost during the Thirty Years War. J. von Sandrart wrote in *Teutsche Academie*, Nuremberg 1657, 1st part, II, 3, p. 236: 'Furthermore, there were, from this noble hand, three altarpieces in the Cathedral of Maynz on the left-hand side of the choir, in three different chapels; each was painted with two wings inside and out.' (Then follows the description of the altarpiece with the *Virgin standing on the Moon*, see p. 94) . . . 'Another panel showed a blind hermit who, walking on

the frozen river Rhine with his guide boy, is attacked by two murderers and beaten to death, falling on to his screaming boy, depicted with such natural and true feelings, accomplishment and amazingly true thought that one can only marvel.'

The connection of the drawing with a representation of the legend of St. Peter Martyr is very vague and is based only on the remark by Sandrart that this picture contained a screaming figure. Both heads on Plates 40 and 41 could equally well belong to singing angels, or even more probably, angels in a Passion picture (according to E. Schönberger *et al.*). Or again, they might have a place in the martyrdom of another saint, perhaps Sebastian (cf. Baldung Grien). W. Fraenger (*Mathias Grünewald, ein physiognomischer Versuch*, Berlin, 1936, p. 100) even thinks of an epileptic, and refers to the *St. Cyriacus* grisaille at Frankfurt. If these two heads, Plates 40 and 41, really were preliminary studies for one of the Mainz Cathedral altarpieces, we would at last have a definite date, since we know from Sulpiz Boisserée that the *Murder of the Blind Hermit*, or rather *St. Peter Martyr*, was dated 1520. About 1810. Boisserée saw at the house of Chamberlain von Holzhausen in Frankfurt . . . 'a small picture, about 2 foot 12 inches (*sic*) wide, showing a blind man being led across the ice by a boy and being beaten to death by two murderers, just as Sandrart described a similar picture by Grünewald, and with these signatures (the monogram of Grünewald's most important artistic heir, Philipp Uffenbach; underneath the date 1520 and the well-known G within M), which is said to have been lost at sea on a voyage to Sweden.' This may possibly have been a copy (W. K. Zülch, *Der historische Grünewald*, Munich, 1938, p. 340).

XXXVI

SCREAMING HEAD (Plate 41)

Chalk, heightened with white; $9\frac{5}{8} \times 7\frac{7}{8}$ in.; 24·4 × 20 cm.
Print Room, Berlin-Dahlem.

Usually connected with the Mainz altarpiece, the centre panel of which was the St. Peter Martyr picture dated 1520, and which was looted by the Swedes and lost at sea (see notes on Catalogue XXXV). This might be the screaming boy on whom the dying man had fallen (according to Sandrart, see quotation above).

There is much to be said for another widely held interpretation of this head as that of a weeping angel in a Passion picture. Such ecstatic displays of emotion can be found in the *putti* of many a *Pietà* from the circle of Donatello or Bellini, as well as in Crivelli, Zoppo and others. On the other hand, the realistic clothes on these two figures

would look incongruous on *putti* holding the dead body of Christ. As these two heads, which in spite of the different techniques clearly belong together, must be among the late, though not the very latest, drawings of Grünewald—irrespective of the date of the *St. Peter Martyr*—there is every probability that both were connected with the painting of the *Murder of the Blind Hermit* dated 1520 (see also pp. 81–2).

XXXVII

HEAD OF A BEARDLESS OLD MAN (Plate 42)

Chalk; 10 × 7½ in.; 25·5 × 19 cm.
National Museum, Stockholm.

In the upper left-hand corner, an unknown hand has added the Dürer monogram; in the lower corner on the left, a later inscription 'albert Durer'. Various attempts to identify the model must be regarded as pure hypotheses (e.g. A. Burkhard suggested Johann Pals [*Mathias Grüne-*wald, *Personality and Accomplishment*, Cambridge, 1936, p. 64], while Zülch regarded it as a portrait of Johann de Indagine [*Grünewald*, Leipzig, 1954, p. 33]). A valuable observation was made by G. Schönberger (*The Drawings of . . . Grünewald*, New York, 1948, No. 36), who pointed out that the position of the head was typical of that of a donor, although it must remain open for which (lost) painting by Grünewald such a donor's portrait may have been intended.

What is certain is that this is one of the most masterly drawings from Grünewald's hand, both in form and expression, and that it must be regarded as a late work, because of its tendency to a heaviness of form (cf. the *Crucifixion* panel, Karlsruhe, Fig. 1), coupled with the half-gloomy, half-calm expression which registers inward rather than outward emotion. Above all, the technical bravura is very similar to that in the *Screaming Head* datable about 1520 (No. XXXVI), which suggests that both are of the same period.

APPENDIX

NOTES ON DOUBTFUL OR MISATTRIBUTED DRAWINGS

To avoid misunderstanding, I must point out that I shall deal only with those drawings which, in my opinion, may have some possible connection with Grünewald. Drawings for which the basis of attribution is purely hypothetical will not be considered although, for completeness, I list them below:

Susanna and the Elders. Formerly Koenigs Collection, Haarlem; Zülch, 1938, p. 331—*Inclined Head*. Print Room, Dresden; O. Benesch, *Burl. Mag.*, October, 1963, p. 449—*Illustrations* Nos. 4, 6a, 9, 19, 30a, 30b in Hans Haug's *Grünewald, Collection des Maîtres*. The same sheets are mentioned by H. H. Naumann in *Mathis Nithart, le premier élève de Martin Schongauer* (*Archives Alsaciennes d'Histoire et d'Art*, 1935). This applies also to the drawings described there as coming from the 'Atelier de Schongauer', and to the graphic works and paintings attributed to the 'young Grünewald' prior to 1503 by Naumann, Haug and others. The most recent example of a misattribution to Grünewald is the sheet with drawings of old women, on both sides, from the G. Bellingham-Smith and Hanning Philipps Collections, which was sold at Sotheby's in London on July 7, 1966 (authenticated by W. R. Valentiner in 1947). I might add that I do not know this sheet in the original.

Another work which must be excluded is the famous *woodcut from the Missale Pragense* of 1522. Its connection with Grünewald's later painting for Halle Cathedral (Alte Pinakothek, Munich) is, of course, unmistakable, but in fact, as is well known, it is by Georg Lemberger. Grünewald neither designed nor executed this magnificent woodcut, but found in it a source of inspiration for one of his masterpieces.

Finally, we will mention, without illustrating them, the copies engraved or drawn by hand after Grünewald drawings. The following are definitely copies of Grünewalds:

Christ with Arms Outstretched (Plate 50). From the Plock Bible, Print Room, East Berlin. After the Grünewald drawing, Plate 9—*Christ on the Cross*, Öffentliche Kunstsammlung, Basle; illustrated by Zülch (1938), p. 168. After the Karlsruhe drawing (Plate 1)—*Christ on the Cross*, Öffentliche Kunstsammlung, Basle. Illustrated by Zülch (1938), p. 169. Supposed copy after a lost drawing by Grünewald. This copy is certainly based on the master's work and has a direct connection with the Isenheim *Crucifixion*. I think it is splitting hairs to claim that the insignificant differences from the painting show that this

copy was made from a lost autograph preliminary study for the Isenheim altarpiece—*Head of a young Girl with loose Hair*. Öffentliche Kunstsammlung, Basle. Illustrated by Zülch (1938), p. 179. According to H. A. Schmid, this is a copy of a preliminary study for the *Angel of the Annunciation* for Isenheim—a hypothesis which cannot be substantiated by any evidence—*Copy after the 'Self-Portrait' in Erlangen*. Picture Gallery, Kassel (cf. notes p. 90). The baroque woodcut bearing the Grünewald monogram G within M and the date 1510, illustrated by Zülch (1938), Fig. 205, must be regarded as copy after Grünewald, but of a painting (perhaps the *Glorification of the Virgin* from the lost Mainz altarpieces, cf. notes on p. 94) rather than a drawing.

The drawing dated 1590, in Göttingen University (Zülch, 1938, Fig. 206), is believed to be a copy by Philipp Uffenbach of a lost preliminary study for the *St. Anthony* of the Isenheim altarpiece.

a—f

THE GRÜNEWALD FIND AT MARBURG

GOD THE FATHER (Plate 43)

Chalk; $12\frac{1}{4} \times 9\frac{1}{8}$ in.; 31×23 cm.

THE VIRGIN WITH TRAIN-BEARING ANGELS (Plate 48)

Chalk; $12\frac{5}{8} \times 13\frac{3}{4}$ in.; 32×35 cm.

FLOATING FEMALE FIGURE, OPENING A JAR (Plate 44)

Chalk; $5\frac{5}{8} \times 9\frac{1}{8}$ in.; $14\cdot2 \times 23$ cm.

FLOATING FEMALE FIGURE WITH THE SUDARY OF ST. VERONICA (Plate 47)

Chalk; $7\frac{1}{2} \times 10\frac{5}{8}$ in.; 19×27 cm.

ST. JOHN THE BAPTIST PREACHING (Plate 46)

Chalk; $12\frac{1}{4} \times 8$ in.; $30\cdot8 \times 20\cdot4$ cm.

ST. PAUL (Plate 45)

Chalk; $10\frac{3}{4} \times 8\frac{1}{8}$ in.; $27\cdot3 \times 20\cdot5$ cm.

These six drawings were found by Otto Brinckmann, a newspaper illustrator of Marburg, in a rubbish heap outside the village of Gisselberg near Marburg at the beginning of December, 1949. They are now in a private collection at Marburg.

In his essay in the *Zeitschrift für Kunstwissenschaft*, vol. VI, No. 3/4, 1952, pp. 155–74, F. Winkler entered into the controversy about their authenticity and helped to clarify the problems surrounding them. The only meaningful contribution I can make is to say that these sheets certainly have a close connection with Grünewald, but in their present state cannot be accepted unreservedly as Grünewald originals. Winkler was of the opinion that the strange impression gained from the 'calligraphy' of these drawings (which he considered genuine) could be explained by the fact that the lines had considerably deteriorated owing to the dampness and other natural influences to which they had been exposed. The problem needs to be examined by a chemist or an experienced restorer. Zülch conjectured that they had been retouched by another hand at a later date (cf. W. K. Zülch, 'Mathis der Maler, ein Grünewald-fund', *Zeitschrift für Kunst*, vol. 4, 1950, p. 91).

A comparison between the drawings found at Marburg and those whose authenticity is beyond doubt shows that the former have the following characteristics:

The contours are unusually broad and firm, almost hard. They lack the spontaneity of line expressive of immediacy of perception. Hatchings are rounded and regular, and the whole work gives a vague impression of roundness not otherwise noticeable in Grünewald's work. Hastily sketched features—such as small trees, rays of light and clouds—have an odd deliberate fixity which is out of character for Grünewald, or, indeed, for any original work. One cannot help feeling that the forms had been predetermined and were not 'discovered' by the draughtsman as he went along, whereas any original Grünewald drawing conveys to the sensitive eye the freshness of new discovery. There is a quiet deliberation in the scumbling, not the feeling of compulsion and excitement that pervades the work of an inspired, creative draughtsman, particularly one of Grünewald's stature. The spiritual content holds no fascination but, on the contrary, is almost repellent with its exaggeratedly expressive manner, which verges on caricature (see, in particular, the *Virgin*, *God the Father*, *Paul* and the *Magdalen*). Even disregarding the foregoing factors, the decisive argument against an untouched Grünewald is a deficiency in technique, which can hardly be overlooked. In spite of the emotive fragility of his calligraphy, Grünewald possessed undoubted technical mastery, which he could never have lost, even when his mental and physical powers were failing. The only exception among this group is the *St. John*, which gives an impression of formal mastery, and is, in my opinion, proof that there is a 'certain something' about the Marburg sheets—but not enough to serve as an argument for absolute originality or authenticity.

All the other drawings are marred by clumsy distortions, either in details or the whole composition. This is most noticeable in the head of *St. Paul*, in Christ's head on the *sudary*, in the whole of the *Floating Female Figure with the Jar* (which shows genius in its composition), but particularly in the *Virgin with train-bearing Angels*. The latter can be compared in composition and theme with Grünewald's

authentic drawing of the *Man kneeling, his Train held by Two Winged Figures* (Plate 30). Let us now imagine that the hastily sketched parts of this genuine drawing were later completed or imitated by a copyist. Let us further imagine that the kneeling figure in the original drawing had faded as a result of moisture or rubbing and was subsequently touched up or copied on to a new sheet because the original had become smudged. If this renovator or copyist possessed only moderate talent, then it is not difficult to imagine that the Berlin drawing would have acquired all the characteristics of the sheet found at Marburg. The renovator or copyist responsible for the Marburg drawing has missed no opportunity of turning into faults whatever ambiguities existed in the authentic original. For example, the heads of the angels and of the Virgin can only be described as dilettantist, devoid of expression, and of poor formal conception. One cannot imagine a living, space-occupying body beneath the billowing garments of the Virgin. The renovator or copyist obviously did not know what to do with Grünewald's—no doubt—correctly sketched indications. This figure, in the condition in which we find it, is without a doubt badly drawn.

With the utmost caution, one might reach the following conclusion: these six drawings, as they have come down to us, are no longer Grünewald originals, but are either badly preserved Grünewald drawings refurbished by somebody of only moderate talent but familiar with Grünewald's style, or they are copies based on lost Grünewald drawings, made by someone familiar with Grünewald—perhaps Grimmer or Uffenbach. Those who have seen the Marburg originals have mentioned both possibilities, without being able to decide in favour of one or the other. Whatever the truth of the matter, it is best to leave at least five of the Marburg drawings out of the authentic Grünewald *oeuvre*, since their imperfections would be painfully incongruous with it. The only drawing which is more or less in keeping with the autograph *oeuvre* is *John the Baptist* (Plate 46), as previously mentioned. Here the pentimenti, which speak for its authenticity, have remained more visible, and thus the drawing as a whole is comparatively closest to an autograph. However, although this *John* bears a certain resemblance to the *St. John* of the Isenheim *Crucifixion*, there are graphic shortcomings. This drawing is perhaps the most convincing indication that, even at best, the connection between the Marburg sheets and Grünewald is only marginal. It is useful to remember the sympathetic understanding with which mannerist imitations of Dürer were made in the second half of the sixteenth century and later!

Nobody would seriously doubt that the Marburg sheets are based on Grünewald 'inventions'. Iconographically, all the motifs seem to be more or less well founded and in keeping with Grünewald's unusual conception, which does not conform to orthodox iconology, but is in accord with the enigmatic world illustrated in books of mystic revelation. Zülch makes an attempt to use the drawings in the reconstruction of one of the three altarpieces of Mainz Cathedral painted in 1520 and last heard of in 1632, the *Glorification of the Virgin* ('Mathis der Maler, ein Grünewaldfund', *Zeitschrift für Kunst*, vol. 4, 1950, pp. 91 ff.). However, this association has no basis and is in contradiction with another, more credible reconstruction of the Mainz Lady Chapel altarpiece based on extant Grünewald drawings (cf. remarks on pp. 94 f). Friedrich Winkler, on the other hand, connects the Marburg drawings with the commission Grünewald obtained from Heinrich Reitzmann to paint a *gloriosissima virgo* for the village church at Oberissigheim about the time of the Isenheim altarpiece ('Der Marburger Grünewaldfund', *Zeitschrift für Kunstwissenschaft*, vol. 6, 1952, p. 163).

Some of the Marburg sheets can, however, be related to the Revelation of St. John. Thus, the floating female figure opening a jar may well be the 'angel carrying a censer of gold' which he 'filled from the altar fire and threw it down upon the earth' (Revelation VIII, 3, 5). And, the floating woman with the sudary is certainly not a Veronica but, as mentioned above, an angel—corresponding with the Dürer etching B 26.

g

HEAD OF MARGARETHE PRELLWITZ
(Plate 49)

Chalk, heightened with white; $11\frac{3}{8} \times 8\frac{3}{4}$ in.; $28 \cdot 8 \times 22 \cdot 4$ cm. Louvre, Paris.

On the back of the drawing an old inscription HANS SCHENECZ MUOTTER, AETATIS SUAE 71'. Below: *margret brellwitzin*. This drawing was first attributed to Grünewald by E. Baumeister ('Eine Zeichnung Grünewalds', *Münchner Jahrbuch*, N.F., vol. III, 1926, pp. 269 ff.). Surprisingly, this view has been accepted by many serious scholars, but apparently, on purely external evidence. If the inscriptions on the back are correct, it is true to say that Grünewald may have known this woman; Margarethe Prellwitz was the third wife of Martin Schönitz, the owner of a salt-mine. Her son, Hans von Schönitz, was a chamberlain and art superintendent at Cardinal Albrecht's court at Halle. Thus, the chamberlain and the artist served the same master, though not at the same time. It is reasonable to assume that even before his official appointment the art-loving courtier had been in contact with the court painter. It has also been claimed that the attribution of this drawing to Grünewald can be reinforced by stylistic arguments, but

this is only possible if one misinterprets the sensitive hesitancy and withdrawn brittleness of line that characterizes Grünewald. The author of this drawing, on the other hand, tries to simulate non-existent skill by means of a clumsy coarseness and ingenious carelessness. Unless one assumes that an unskilled botcher has touched up a fading original with a complete lack of understanding (a possibility which is vaguely suggested by one or two minor points of this drawing), it would be best to dismiss this unsatisfactory drawing from Grünewald's *oeuvre* altogether, as it is painfully incongruous with the uniformly high quality of the rest of his work. Anyone who has grasped the profound knowledge of proportions and mysteries of form which animates even Grünewald's most delicate line; anyone who knows the meaning of 'good draughtsmanship', will see proof *against* this attribution to Grünewald in the misshapenness of the head as a whole, in the completely wrong position of the eyes, and in the petty caricature evident in the shaping of nose and mouth.

h

MADONNA OF MERCY (Plate 51)

Pen drawing; 12⅜×9¼ in.; 31·5×23·4 cm.
National Museum, Stockholm.

Edmund Schilling, with whom I had a protracted correspondence on the subject of this drawing, establishes a 'relationship with Grünewald' of this 'pen drawing of the sixteenth century' (the title of his reasoned essay, in *Städel-Jahrbuch*, vol. IX, 1935–6, pp. 97–107). Since there is nothing comparable in Grünewald's authentic *oeuvre*, both in regard to technique (pen drawing) and to form (sketch for a complete composition), we are faced with great difficulties. Certain markedly calligraphic elements, which were widespread in German pen drawings of the time, do not completely correspond with the general impression of Grünewald's more rugged style. This applies, in particular, to the curved parallel lines in some parts of the drapery, where it is not clear whether they are intended to indicate shade hatchings or dense folds. To be fair, we must admit, however, that a similar style can be found in some of Grünewald's drawings, e.g. Plates 20, 21, 37 and 42.

What does not fit in, however, is, above all, the figure of the Virgin, which is conventional in form and superficial in expression. One is reminded of some mediocre draughtsman of the Danube School. But both technique and invention are finer and more precise in the heavenly figures in the upper half of this composition, and in the crowds kneeling in prayer. Where Schilling connects this drawing with the *Maria-Schnee* panel at Freiburg, and even suggests that it was a study for the centre panel of the *Maria-Schnee* altarpiece, his theory must be rejected if the *Madonna of Stuppach* (Fig. 8) is identified with this centre panel. However, from the stylistic point of view such a connection would support this attribution because the Freiburg *Miracle of the Snows* (the only picture positively proved to belong to the Aschaffenburg altarpiece) shows similar characteristics of early mannerism as the Stockholm pen drawing. It was at that time, in 1519, that Grünewald paid tribute to this international style. Schilling himself demonstrates the affinity of this drawing with the painting: the men kneeling in prayer, illustrated on pages 102 and 104 of his article, have indeed much in common with a detail from the *Miracle of the Snows* painting with which he compares them, both in expression and in the peculiarly careless calligraphy.

The attribution of this pen drawing to Grünewald is at least credible, and in several new Grünewald books it is listed among his own works. In my opinion, however, caution makes it advisable to leave this spirited, though far from important, drawing among the uncertain attributions.

LIST OF LOCATIONS

BERLIN-DAHLEM, Print Room

Young man clasping his hands, No. II, Plate 5
Virgin of the Annunciation, No. IV, Plate 4
Kneeling man gesticulating, No. X, Plate 11
St. Dorothy, No. XI, Plate 13
Virgin of the Annunciation, No. XII, Plate 12
Head of a young woman, No. XXIII, Plate 26
Study for the Madonna of Stuppach, No. XXIV, Plate 28
Kneeling man, his train held by two winged figures,
 No. XXV, Plates 29, 30
Madonna and Child with St. John, No. XXVIII, Plate 33
St. Catherine, No. XXXII, Plate 36
Female Saint, No. XXXIII, Plate 38
Trias Romana, No. XXXIV, Plate 39
Screaming head, No. XXXV, Plate 40
Screaming head, No. XXXVI, Plate 41

EAST BERLIN, Print Room

Man running, with outstretched arms, No. VII, Plate 9
Youth standing, his right hand raised in blessing, No. VIII,
 Plate 8
Bearded man standing, No. IX, Plate 10
Study for the bust of St. Sebastian, No. XIX, Plate 23
St. Anthony, No. XXI, Plate 25
Christ (copy), cf. No. VII, Plate 50

DRESDEN, Print Room

Falling man seen from the back, No. V, Plate 6
Falling man seen from the side, No. VI, Plate 7
Study for the bust of St. Sebastian, No. XVIII, Plate 22
Study for the St. Anthony of the Isenheim altarpiece,
 No. XX, Plate 24

ERLANGEN, University Library

So-called self-portrait, No. XXII, Plate 27

HAARLEM, F. Koenigs Collection (formerly)

Nude flute-player, No. XXX, Plate 35

KARLSRUHE, Staatliche Kunsthalle

Christ on the Cross, No. I, Plates 1, 2

LUETZSCHENA, Collection Speck zu Sternburg
(formerly)

Woman looking upwards, No. XIV, Plates, 17, 18
Young woman looking upwards, No. XXIX, Plate 34

MARBURG, Privately owned

God the Father, Appendix: a, Plate 43
Virgin with train-bearing angels, Appendix: b, Plate 48
Woman with jar of ointment, Appendix: c, Plate 44
Woman with the sudary of St. Veronica, Appendix: d,
 Plate 47
John the Baptist preaching, Appendix: e, Plate 46
St. Paul, Appendix: f, Plate 45

NORTHAMPTON, Mass., Smith College Museum of
 Art

Drapery study, No. III, Plate 3

OXFORD, Ashmolean Museum

Woman mourning (half figure), No. XVI, Plate 20

PARIS, Louvre, Cabinet des Dessins

Head of a woman, No. XVII, Plate 21
Head of Margarethe Prellwitz, Appendix: g, Plate 49

ROTTERDAM, Museum Boymans—Van Beuningen

The Virgin standing on the moon, No. XXXI, Plate 37

STOCKHOLM, National Museum

Head of a beardless old man, No. XXXVII, Plate 42
Madonna of Mercy, Appendix: h, Plate 51

VIENNA, Albertina

Standing saint praying, with sword and pilgrim's staff,
 No. XXVI, Plate 32
St. Peter, No. XXVII, Plate, 31

WEIMAR, Schlossmuseum

Head of an old man in profile, No. XIII, Plate 14

WINTERTHUR, Oskar Reinhart Foundation

Woman mourning (half figure), No. XV, Plates 15,
 16, 19